IMAGES
of America

DURHAM
NORTH CAROLINA

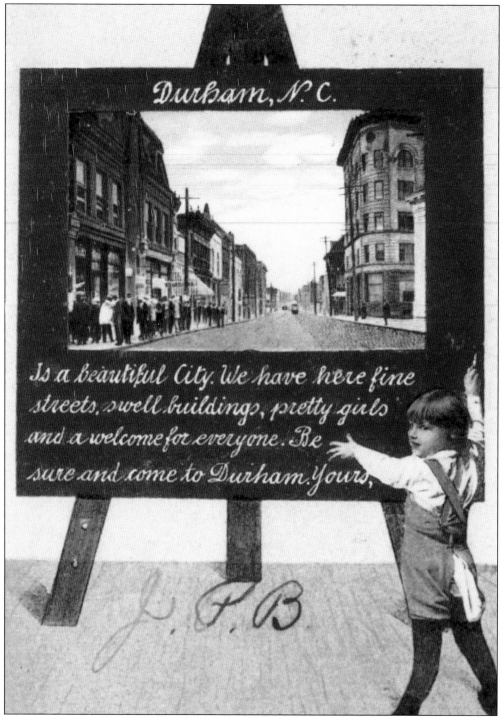

Durham, N.C.

Is a beautiful City. We have here fine streets, swell buildings, pretty girls and a welcome for everyone. Be sure and come to Durham. Yours,

J. F. B.

Greeting cards, such as the one exhibited here, were popular among the traveling public and collectors alike. Postcards were published to promote a community and to attract visitors to an area. The purchaser of this card sent it to Philadelphia in 1909 with the message: "Please send a better looking card next time. This is a nice town." (Postcard supplied courtesy of B.T. Fowler.)

IMAGES
of America

DURHAM
NORTH CAROLINA

Stephen E. Massengill

ARCADIA
PUBLISHING

Published by Arcadia Publishing
Charleston, South Carolina

Printed in the United States of America

For all general information contact Arcadia Publishing at:
Telephone 843-853-2070
Fax 843-853-0044
E-mail sales@arcadiapublishing.com
For customer service and orders:
Toll-Free 1-888-313-2665

Visit us on the Internet at www.arcadiapublishing.com

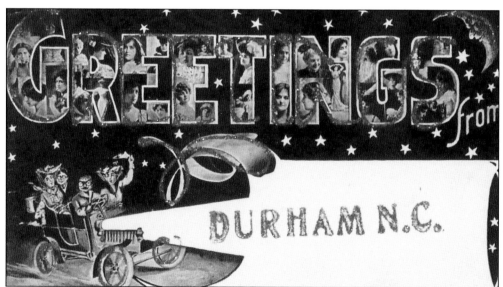

Shown above is another example of a greeting card. This one was purchased in Durham and mailed to Oxford in 1908. The generic format of this postcard allowed the postcard distributor to add the appropriate place-name to the headlight of the automobile. This type of postcard was utilized to extend a warm welcome to numerous communities throughout the nation.

Contents

Acknowledgments

I could not have undertaken this publication without the assistance of many people. Initially, I wish to thank all of the individuals and institutions that provided postcards and prints for reproduction in the book. Those contributors include Durwood Barbour, the Duke University Archives, B.T. Fowler, Leigh H. Gunn, Aubrey T. Haddock, Betsy M. Holloway, Willard E. Jones, the North Carolina Division of Archives and History, Sarah M. Pope, B.W.C. Roberts, and the Special Collections Library at Duke University.

Others who helped with the completion of this work include Norman D. Anderson, Mary Anne Barbour, Ann M. Berkley, Robert M. Carlew, Virginia P. Doughton, Jim Edgerton, Clayborne L. Evans Jr., Tom Fowler, Tommy Gunn, Jim Harward, Dr. Rufus M. Holloway Jr., William E. King, Russell S. Koonts, Monnie Lusky, Synkari Menolek, Chuck Milligan, Janie C. Morris, Dr. William P. Peete, Snow L. Roberts, Jim L. Sumner, Judith Topkins, Patricia S. Webb, Alan L. Westmoreland, and the staff of the State Library of North Carolina.

Special gratitude is extended to Betsy M. Holloway and B.W.C. Roberts, whose passion for Durham's past has been an inspiration to me. They have offered encouragement and have shared with me their vast knowledge of the history of Durham, as well as their considerable bibliographic resources.

I direct my deepest appreciation to my good friend and colleague Robert M. Topkins, who expertly edited the manuscript, entered it into the computer, and prepared the index. In addition, I wish to express gratitude to my wife, Caroline Warren Massengill; to our daughters, Carla and Stacey; and to my mother, Doris, for their support throughout this project.

I dedicate this volume to my relatives who migrated to Durham in the early twentieth century and played a small part in the development of the city. They represent the multitude of men and women who left rural areas of North Carolina and nearby states for the more stable, yet demanding, industrial jobs in the "Bull City." My maternal grandfather, John Arch Campbell (1888–1970), worked for many years at Erwin Cotton Mills, and my paternal grandfather, Ransom Jackson Massengill (1900–1982), was employed for more than fifty years at Durham Hosiery Mill. Ransom's wife, Bertha Jenkins Massengill (1905–1988), worked at Louise Knitting Mill in East Durham. My mother, Doris Campbell Massengill, and her brother, Glenn Reid Campbell, were faithful employees of Liggett and Myers Tobacco Company. My mother, as well as her sister Dorothy Campbell Nash, also worked for Erwin Cotton Mills.

Introduction

Picture postcards were first introduced in the United States in 1893. They quickly became a popular and inexpensive form of communication, and collecting and exchanging view cards became a common pursuit of many Americans. Publishers began producing postcards of North Carolina cities and towns shortly after 1900, and the earliest known postcard view of Durham dates from about 1904. Hundreds of different scenes of the city were made during the first half of the twentieth century. Postcard views now serve as important visual resources in documenting the early physical appearance of Durham.

Durham is still a young city, having developed around a railroad station along the North Carolina Railroad in the early 1850s. After the Civil War, the thriving tobacco-manufacturing industry enabled the town to grow slowly but steadily during the remainder of the nineteenth century. The coming of Trinity College, the continued expansion of the tobacco industry, the development of the textile industry, and the evolution of black-owned enterprises led to a substantial increase in Durham's population in the first quarter of the twentieth century. That period of growth paralleled the so-called "golden age" of postcards (1905–1925), and thus the medium was able to frame and capture much of the development and expansion of the city during those years.

The majority of the views reproduced in this book were manufactured before 1940. The compiler examined more than one thousand postcards of Durham from a variety of sources—including his personal collection, the accumulations of fellow card collectors, and the holdings of local repositories—before selecting the more than two hundred cards included in the volume.

A publication that relies exclusively upon postcards for illustration faces several disadvantages. The limited number of available images results in an incomplete picture of a community. Commercially produced postcards primarily depict "Main Street" views and tend to ignore outlying areas; they tend to showcase the most positive or "progressive" aspects of a city's built environment, often at the expense of equally noteworthy examples; and they frequently overlook entirely the activities and gathering places of minority groups. (For example, the compiler was unable to locate even one early picture postcard depicting St. Joseph AME Church, a landmark African-American house of worship; any synagogues; or any all-black fire companies, despite a systematic search for such images.) Moreover, commercially produced color-tinted postcards are much more difficult to reproduce than are black-and-white photographs. For that reason the compiler chose to include in the book a liberal representation of real-photo postcards in the hope that they would maximize the overall quality of the reproductions.

Postcards accompanied by captions that do not include a credit line are from the compiler's personal collection. The compiler has taken the liberty of inserting into a few such captions brief personal reminiscences and has occasionally included in the captions interesting quotations from messages scribbled on the backs of the cards.

Several picture histories of Durham have been published, but this is the first pictorial work illustrated exclusively with postcards. The compiler has divided the work into nine sections as a means of imparting order and flow to the material selected for inclusion. In addition, the compiler has included biographical information about important figures in the city's history. The publication has been carefully researched for correctness of facts and dates, but in a work of this scope it is difficult if not impossible to attain perfection. It is the compiler's hope that this visual record will prove enjoyable to all readers and especially to those with a fondness for Durham's past.

About Postcards

Deltiologists, or postcard collectors, are frequently asked about postcards. How long have picture postcards been produced? If a card is not postmarked, is there any way of estimating its age? What is the easiest way to determine the value of a card?

The term *postcard* describes privately printed cards that usually have a picture or message on one side, while cards printed by the government are called *postal cards*. Postcards have been around for about one hundred years, and most can be classified according to their date of publication. The following list describes the types of cards that were produced during each era:

Pioneer Cards (1893–1898). These cards are quite rare; many of them are labeled as "Souvenir Postcards." Thus far the compiler has not identified any pioneer cards of Durham.

Private Mailing Cards (1898–1901). These cards have the term "Private Mailing Card" printed on the address side, usually along with the statement: "Authorized by Act of Congress of May 19, 1898." Private mailing cards of Durham are very scarce, and none are included in this book.

Undivided Backs (1901–1907). Cards printed during this period are called *undivideds* because existing postal regulations did not allow messages to be written on the back of the card, that is, the side reserved for the address of the recipient. The same regulations applied to pioneer and private mailing cards. The earliest known Durham postcards featured undivided backs.

Divided Backs (1907–World War I). Effective March 1, 1907, the United States Post Office Department approved the divided back, which allowed the backs of postcards to be divided into left- and right-hand portions, providing space for written messages on the left and for addresses on the right. Many of the undivided- and divided-back cards were published in England and Germany, and there are many fine examples in this publication.

White Borders (World War I–1930s). After World War I, most of the cards sold in the United States were printed in this country. Since many of them had a white border, the term is used to describe cards published during that period. Many of the cards in this book fall into this category.

Linens (1930s–1940s). These cards have a rough finish and gaudy colors and were made from paper with a high rag content. Some of the more recent cards in this work, such as those depicting the bus station, the post office, the Stanford L. Warren Public Library, the Little Acorn Restaurant, and Durham High School, are linens.

Chromes (1940s–present). These cards are printed mainly in color, and most resemble a photograph made from a color slide. Some examples of this type of card are the ones that depict Five Points, the Raleigh-Durham Airport, the North Carolina Mutual Life Insurance Company, Durham Athletic Park, and the Research Triangle Park.

As with any classification system, there are exceptions. For example, real-photo cards are printed on photographic paper with the word *Postcard* and a stamp box printed on the back. These are currently among the most collectible categories, and thirty-five real-photo postcards of Durham have been included in this book.

Flea markets, yard sales, antique shows, and auctions are all sources for postcards. Or you may want to attend one of the dozens of postcard shows held across the country each year. How much will you have to spend for postcards? The answer depends on the kind of cards you wish to collect, their age, their condition, and their popularity with other collectors. The prices of the cards in this publication range from less than $1 to more than $30. Among the least expensive are linens and chromes. The real-photo cards carry a high price tag, but the most expensive postcards reproduced in the book are the Bull Durham Smoking Tobacco advertising cards.

One

Town Scenes:
A Changing Skyline

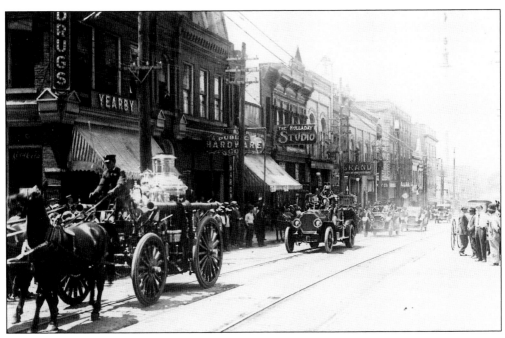

Spectators watch a parade moving east on Main Street near the intersection of Corcoran Street in the early 1910s. It is likely that the procession was part of the annual Confederate Memorial Day observance on May 10. Perhaps it was one of the last appearances of horse-drawn fire engines, which soon gave way to motorized vehicles. Photographer Waller Holladay (b. 1874) may have taken the picture, since his studio is clearly visible at the center of the photograph. (Courtesy of Special Collections Library, Duke University.)

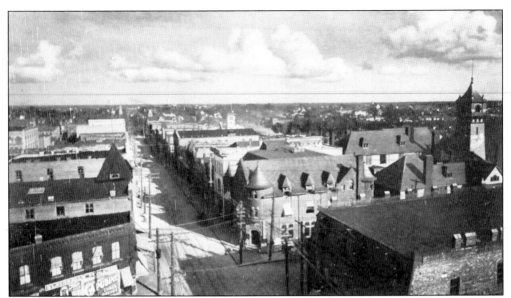

This is an elevated view of Main Street looking east from Corcoran Street about 1905. The photographer took the picture from the top of the Loan and Trust Building, Durham's first skyscraper. The building in the left foreground housed Blacknall's Drugstore. The structure with the cone-shaped cupola (center) is the First National Bank. Visible on the right is the tower of the Hotel Carrolina.

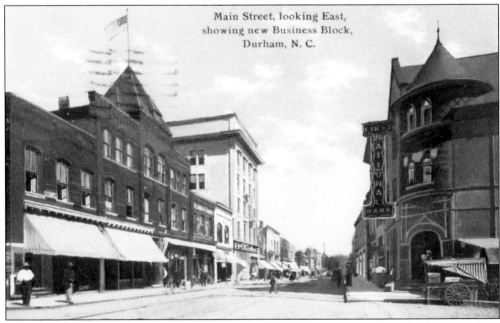

The cameraman returned to street level to capture this view of Main Street looking east from Corcoran Street about 1911. The five-story building in the center is the newly constructed Brodie L. Duke Building, and the edifice at right is the First National Bank.

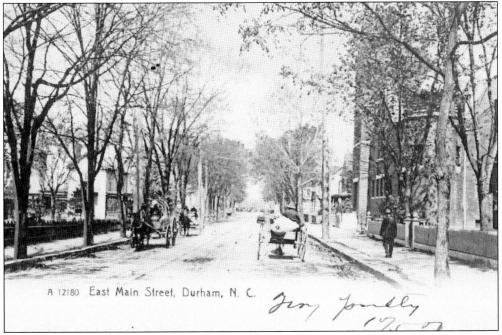

A 12180 East Main Street, Durham, N. C.

This tree-lined view of East Main Street facing west is dated about 1906. Horse-drawn conveyances dominate the unpaved thoroughfare. On the right is the First Presbyterian Church, which stands near the corner of Roxboro Street.

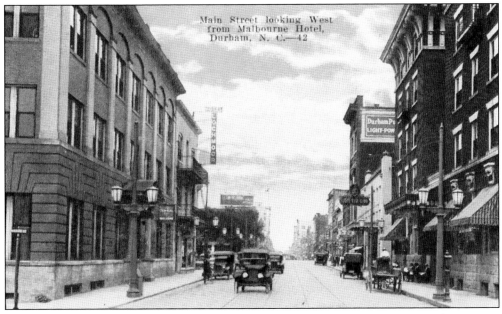

Main Street looking West
from Malbourne Hotel,
Durham, N. C.—42

Reproduced here is a ground-level view of East Main Street looking west from Roxboro Street in the 1910s. Automobiles fill the roadway near the YMCA (left) and the Hotel Malbourne (right). Other landmarks farther west in the picture are the Hotel Lochmoor (next to the YMCA) and the Orpheum Theater (adjacent to the Malbourne).

The Durham Traction Company, in appreciation for the city merchants' purchase of electric signs, presented this sign to the city in December 1913. Workmen placed it atop the roof of a three-story building that stood at the northeast corner of Main and Church Streets. The 41-foot-long-by-31-foot-high sign, which flashed twelve hundred electric lights, was topped by a 10-foot sphere representing the world. The sign stood until 1919, when strong winds toppled it, damaging it beyond repair.

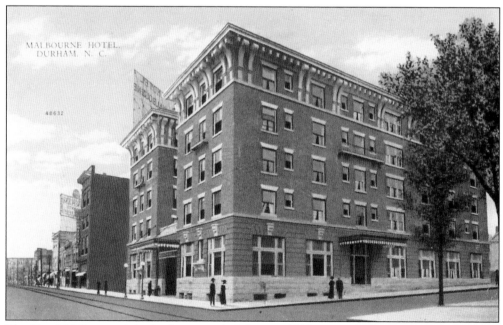

The Hotel Malbourne is in the foreground of this pre-1919 view, which pinpoints the location of the slogan sign, about one-half block west of the hotel.

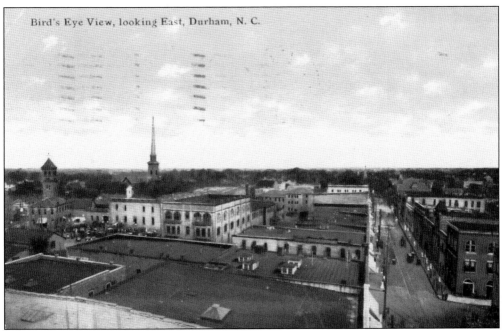

The photographer positioned himself atop the Brodie L. Duke Building, on the north side of Main Street, to take this elevated photograph, looking east, about 1911. The two tall landmarks visible in the distant skyline are the No. 1 Fire Department (tower) and the Trinity Methodist Church (steeple).

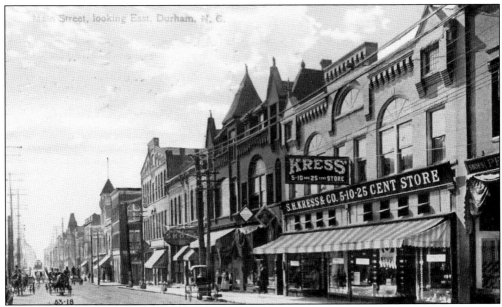

This image shows the location of the S.H. Kress and Company store on the south side of West Main Street about 1913. In the early 1930s, the popular department store vacated this two-and-one-half-story Queen Anne building, believed to have been erected in 1893, and moved a few doors east into a new four-story Art Deco structure. The western half of the original building occupied by Kress still stands at 111 West Main Street.

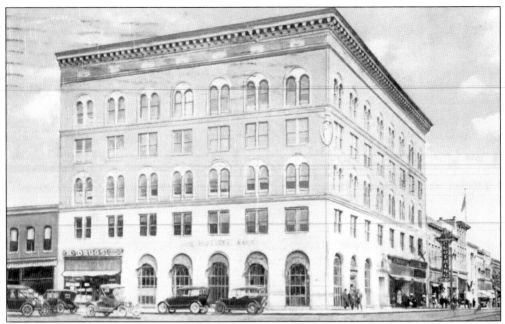

The subject of this postcard is the Geer Building, situated at the corner of Main and Corcoran Streets. The building was headquarters for the Fidelity Bank, and the F.W. Woolworth Company rented a portion of the ground floor. In 1920 a female traveler from Danbury, Connecticut, sent the view home to her children with the following message: "Where I have made a cross is the 10¢ store where I bought these cards." The building is no longer standing.

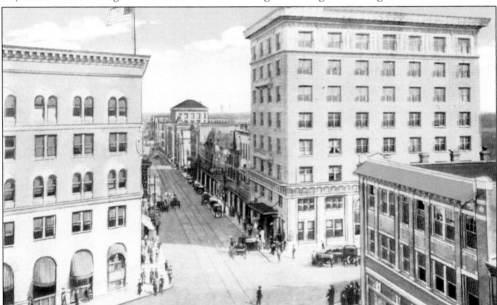

Here is a 1920s elevated view, looking east, from atop the post office, located on the corner of Main and Corcoran Streets. The Geer Building is on the left, facing the eight-story First National Bank across the street. In the right foreground is the Richard H. Wright (1851–1929) Corner, later occupied by Croft Business School and currently the site of a branch of Wachovia Bank and Trust Company.

14

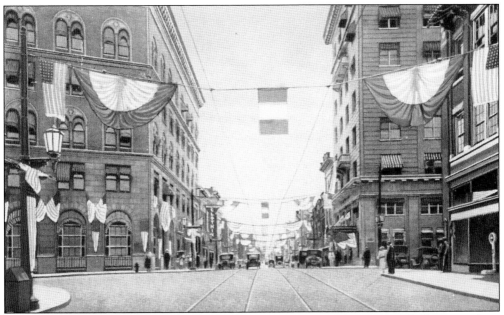

Flags and bunting decorate the city in this mid-1920s image of Main Street looking east from Corcoran Street. At left is the Geer Building, and opposite is the First National Bank.

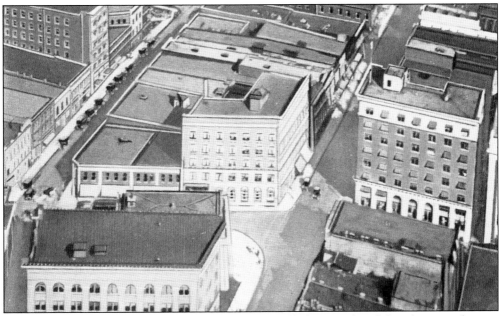

With the advent of the airplane, cities could show off photographs of their business districts from the air. This mid-1920s "aeroplane" view of Durham shows Corcoran Street connecting Parrish and Main Streets in the center of the city. At the upper left on Parrish Street is the six-story building of the North Carolina Mutual Life Insurance Company. Clockwise from the bottom left on Main Street are the Trust Building, the post office, the Geer Building, and the First National Bank (the tallest structure).

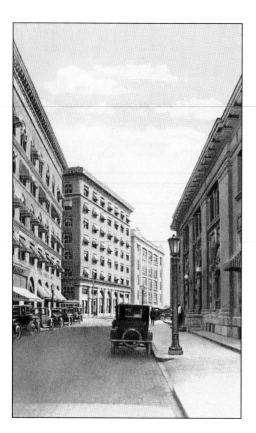

This is a popular vertical view of the heart of the commercial district looking south on Corcoran Street in the 1920s. Left to right are the Geer Building, the First National Bank, Durham Hosiery Mill, and the post office.

By the 1930s the Corcoran Street cityscape had been altered to include the seventeen-story Hill Building (with flag) and the Washington Duke Hotel (1924). Between 1935 and 1937 industrialist and financier John Sprunt Hill (1869–1961) used private funds to construct the 111 Corcoran Street skyscraper, which was designed by the New York firm of Shreve, Lamb and Harmon, architects of the Empire State Building.

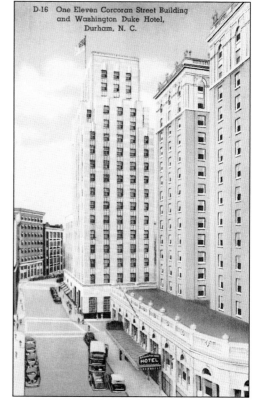

D-16 One Eleven Corcoran Street Building and Washington Duke Hotel, Durham, N. C.

HOTEL

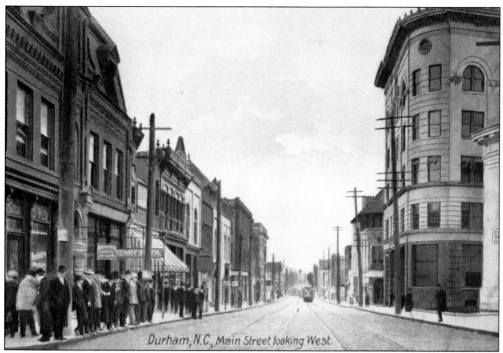

Shown here are two similar views looking west from the intersection of Main and Corcoran Streets prior to 1910. At left is Hackney's Pharmacy (on the Wright Corner), and across the street, left to right, are the Temple Building, the Loan and Trust Building, and the post office. (Image at bottom courtesy of Sarah M. Pope.)

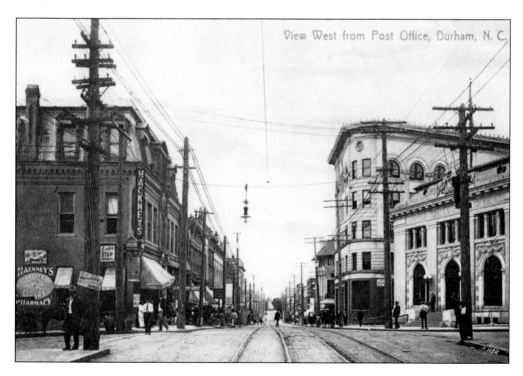

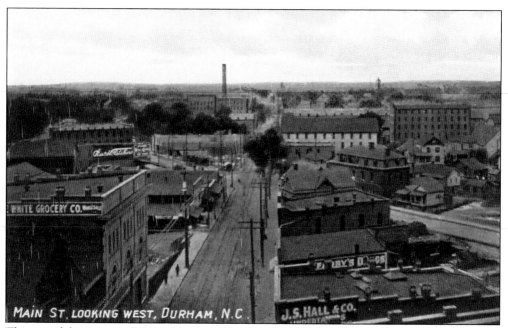

The top of the Loan and Trust Building served as the vantage point for this bird's-eye view of the city looking west toward Five Points and taken prior to 1910. The smokestack of the W. Duke, Sons and Company tobacco factory is visible along the western horizon. (Courtesy of Willard E. Jones.)

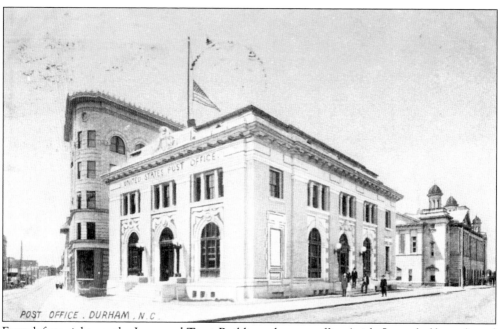

From left to right are the Loan and Trust Building, the post office (with flag at half-mast), and the Municipal Building and Academy of Music about 1908. The position of the camera was near the intersection of Corcoran and Main Streets.

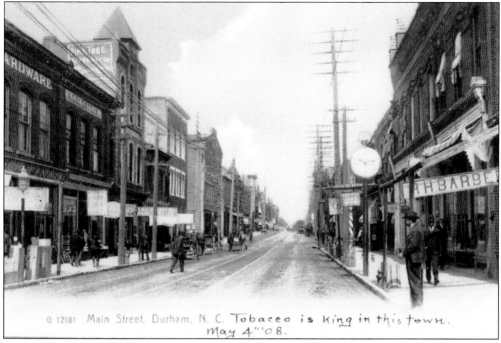

G 12181 Main Street, Durham, N. C. Tobaceo is king in this town.
May 4'' 08.

In this view (c. 1908), looking west on Main Street between Church and Mangum Streets, most of the traffic consisted of horse-drawn vehicles and pedestrians. Beneath the picture, the sender of the postcard inscribed the insightful words: "Tobacco is king in this town."

Main Street is almost deserted in this real-photo card made about 1910. From the photographer's perspective (looking westward), the taller structures at right (the north side of Main Street) are the Brodie L. Duke Building and the Loan and Trust Building.

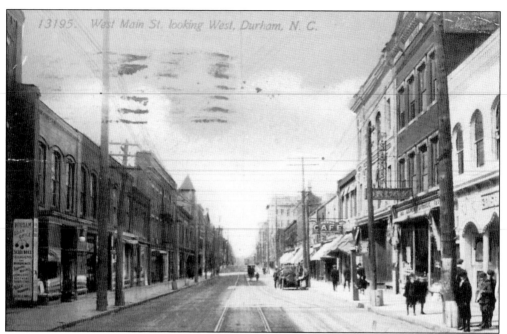

This postcard offers another image of Main Street—a view looking west between Church and Mangum Streets about 1912. The identified businesses on the north side of the street (at right) are the Edisonia Theater, Yearby's Drugstore, and the Royal Café. (Courtesy of Willard E. Jones.)

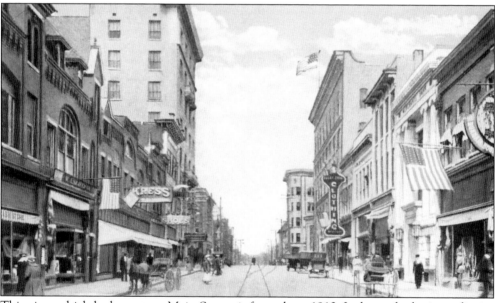

This view, which looks west on Main Street, is from about 1913. It shows the business district between Mangum and Corcoran Streets. On the left side are, from left to right, W.A. Slater's Clothing Store (with flag), S.H. Kress and Company, and the First National Bank (the tallest building). A few recognizable enterprises on the right are the Durham Book and Stationery Company (with large flag), the Merchant's Bank, the Brodie L. Duke Building (with flag on top), and the Loan and Trust Building.

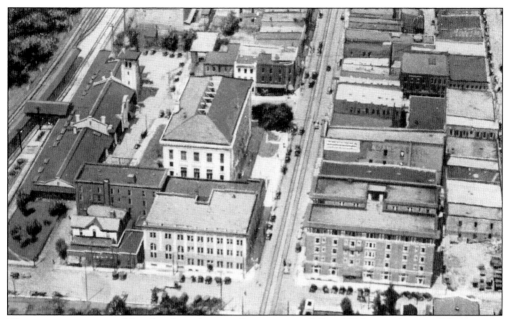

The cameraman was obliged to board an airplane to record this 1920s aerial view of the section around the Durham County Courthouse on Main Street, near the intersection of Roxboro Street. At left, behind the courthouse, is Union Station (with tower). In the left foreground is the YMCA, and directly across Main Street is the Hotel Malbourne.

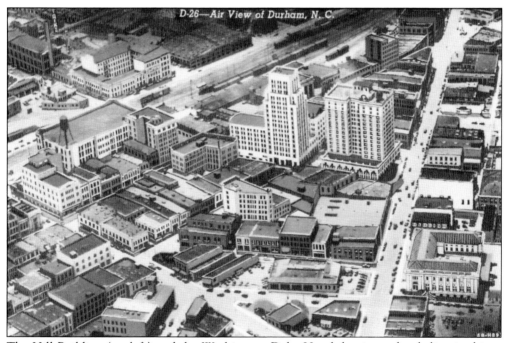

The Hill Building (on left) and the Washington Duke Hotel dominate the skyline in this c. 1940 aerial photograph. Chapel Hill Street, to the right of the hotel, skirts the present-day post office, situated at the bottom right-hand corner of the card. In the upper left-hand corner is the American Tobacco Company, and at the upper right is Five Points.

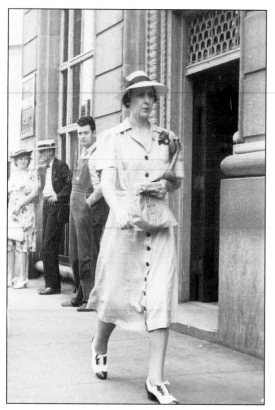

An unidentified woman strolls past onlookers near the Fidelity Bank on the north side of Main Street near Corcoran Street about 1940. Main Street was often crowded with shoppers and workers during this era.

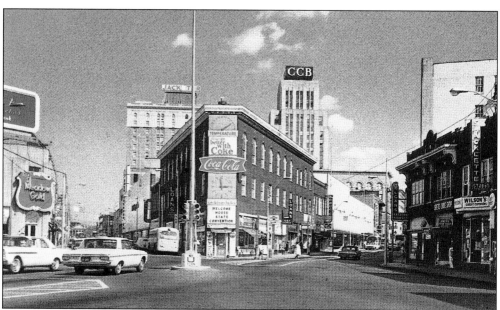

One of Durham's best-known locations is the site at which Main, Chapel Hill, and Morris Streets converge to form Five Points. Here is a view of the area, looking east, during the 1960s. The city changed the name of Five Points to Muirhead Plaza in the 1970s in honor of William Muirhead (d. 1976), founder of a successful construction business in Durham.

Two

Public Places

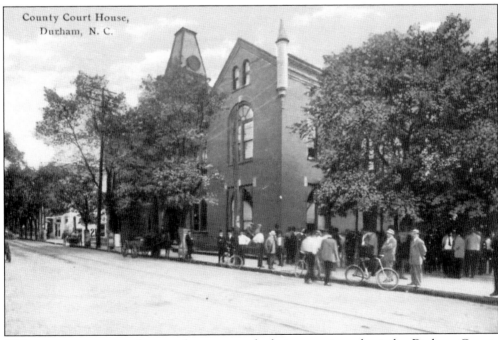

County Court House,
Durham, N. C.

Citizens congregate on the courthouse grounds during court week at the Durham County Courthouse on Main Street about 1910. The North Carolina General Assembly had established the county in 1881. The building, completed in 1889, was the first structure to be designed as a courthouse for the county. During the first eight years of the county's existence, judicial and other county business was conducted at Stokes Hall (also known as the opera house) at the northeast corner of Main and Corcoran Streets. (Courtesy of Willard E. Jones.)

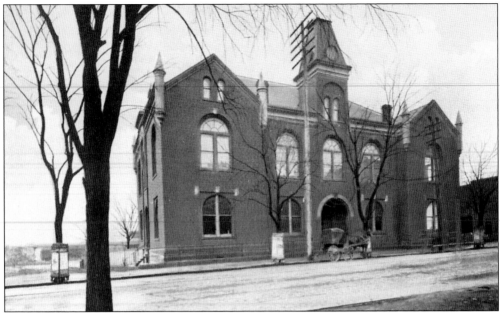

Pictured here (before 1910) is a full frontal view of the brick Victorian courthouse situated on the south side of East Main Street near Church Street. Architect Byron A. Pugin designed the building, which remained in use for twenty-seven years.

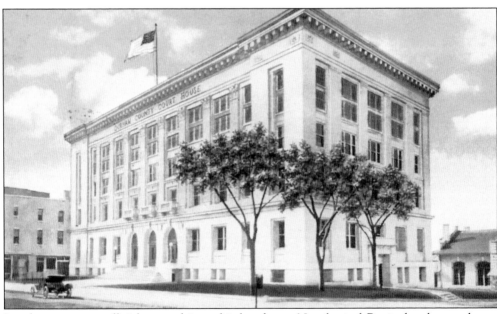

Local government officials moved into this handsome Neoclassical Revival-style courthouse on the south side of Main Street upon its completion in 1916. Designed by the architectural firm of Milburn (Frank P.) and Heister, it stands on the site of the 1889 courthouse, which was demolished. At right, a portion of the Union Station is visible in this 1920s picture postcard. As a youngster in Durham, the compiler recalls the prisoners' jeering taunts from the open windows of the jail on the top floor. In 1978 the county erected the Durham County Judicial Building on the north side of Main Street as a modern alternative to the 1916 courthouse.

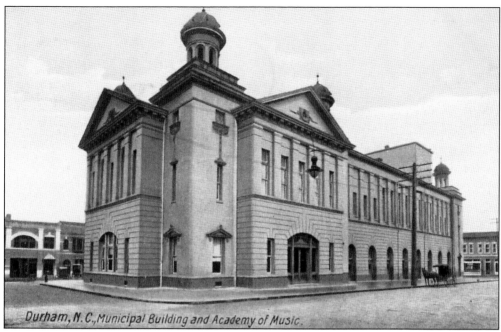

Durham, N. C., Municipal Building and Academy of Music.

In 1903 the City constructed the Municipal Building and Academy of Music, bound by Chapel Hill, Corcoran, Parrish, and Market Streets. This is a view of the Corcoran Street side of the building about 1908. The first floor contained a city market and offices, while the second story held the Academy of Music theater, with a seating capacity of fifteen hundred. A fire gutted the building on June 17, 1909.

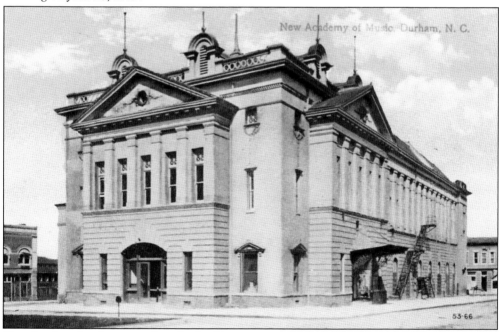

New Academy of Music, Durham, N. C.

Shortly after the disastrous fire, the building was restored to approximately its original form. The "New Academy of Music" provided entertainment for the community until the early 1920s, when it was razed to make way for the Washington Duke Hotel.

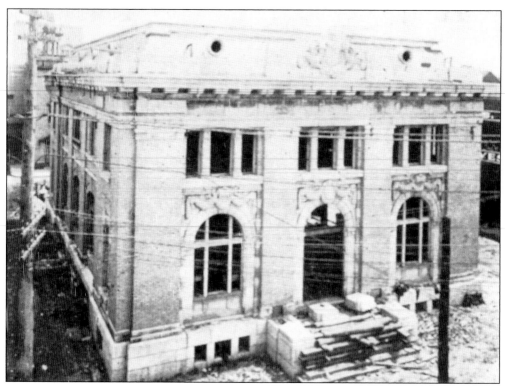

This 1906 view of the new post office shows the building just prior to its completion. Located on Main Street and adjacent to the Loan and Trust Building, it was erected at a cost of $125,000.

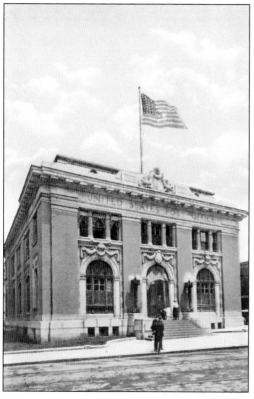

The United States Post Office, which stood at the corner of Main and Corcoran Streets, served the city until 1934, when the increased volume of postal business forced it to move into larger quarters on Chapel Hill Street.

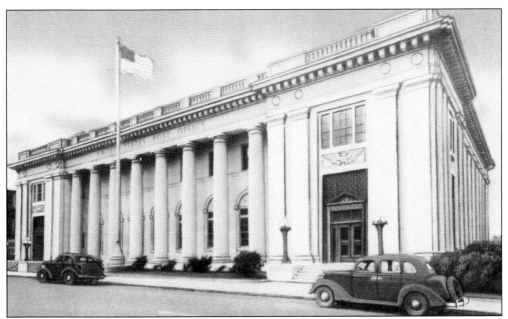

In 1934 the federal government completed its new Durham Post Office at 323 East Chapel Hill Street. The cost of the Neoclassical Revival-style building was $300,00. The facility sold many millions of dollars worth of internal revenue tax stamps to Durham's multibillion-dollar tobacco industry. The complex still serves the downtown community.

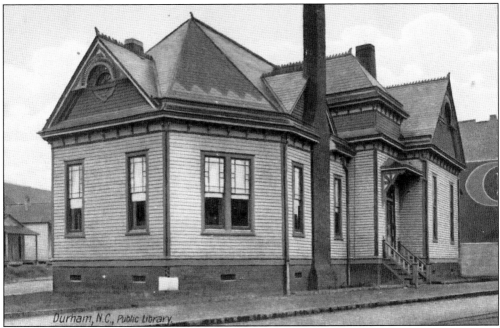

Durham held the distinction of having the first public library in North Carolina to be operated without fees. The facility opened in this wood-frame structure at Five Points in February 1898 and continued in service until 1921. This photograph, dated about 1907, shows the rear of the structure, which resembles a residence more than a public library. The city currently is celebrating the centennial of its library system.

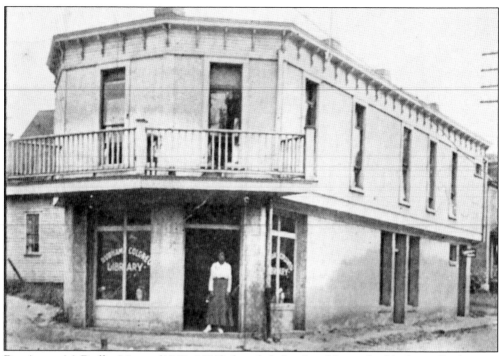

Dr. Aaron McDuffie Moore (1863–1923) founded the first library for blacks in Durham in 1913 at White Rock Baptist Church. By 1916 he had moved it to this building at the corner of Fayetteville and East Pettigrew Streets. Mrs. Hattie B. Wooten (c. 1888–1932) was the first librarian, and she probably is the woman shown standing in the doorway. (Courtesy of Aubrey T. Haddock.)

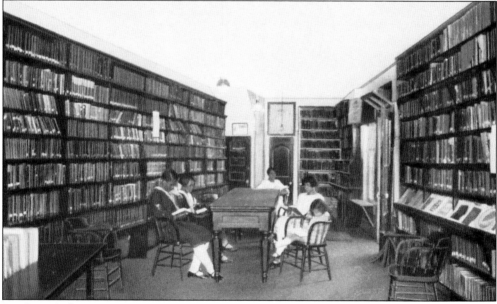

Readers of all ages are shown seated at a table in this unusual interior scene of the Durham Colored Library about 1930. This facility was utilized by the reading public until 1940 and is no longer standing.

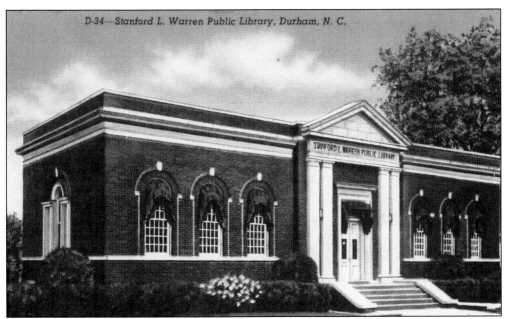

The Stanford L. Warren Public Library opened in January 1940 on the east side of Fayetteville Street. It was the successor to the Durham Colored Library and was named for Dr. Warren (1863–1940), a physician, businessman, and civic leader who served as chairman of the library board for many years and donated land for the new library. The building was renovated in 1985 and is a satellite branch of the Durham County Public Library. (Courtesy of Betsy M. Holloway.)

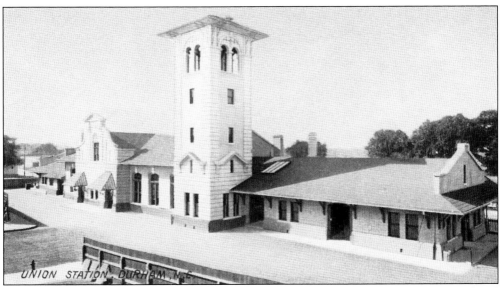

Upon the completion of Union Station in 1905, Durham boasted of having the best railroad facilities in the state. Located off Main Street, at the foot of Church Street, the Italian Renaissance Revival-style building was designed by the firm of Milburn and Heister. The Southern, the Seaboard Air Line, and the Norfolk and Western railway companies built the station, which was considered one of the most important examples of railway architecture in the South.

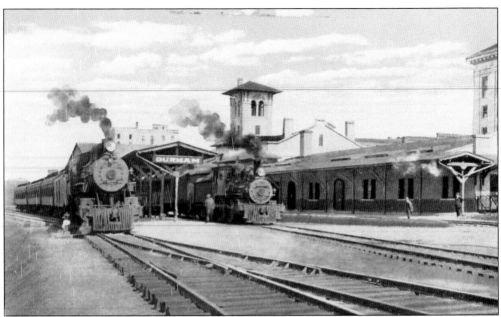

The 65-foot tower of the $50,000 station was its most distinctive feature. In its heyday, as many as twenty-six passenger trains stopped at the station each day. The postcard depicts two steam-driven trains waiting to pull away from the depot about 1920. At right is the southwestern corner of the Durham County Courthouse.

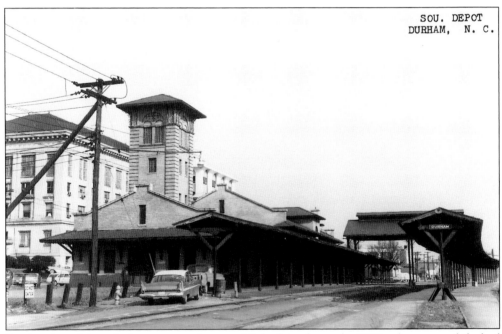

SOU. DEPOT
DURHAM, N. C.

By the time this real-photo postcard was published in the early 1960s, the automobile had greatly curtailed rail passenger service, and the days of the station were numbered. Rail service was discontinued in 1966, and, ironically, the City demolished the building the following year to make way for a traffic loop.

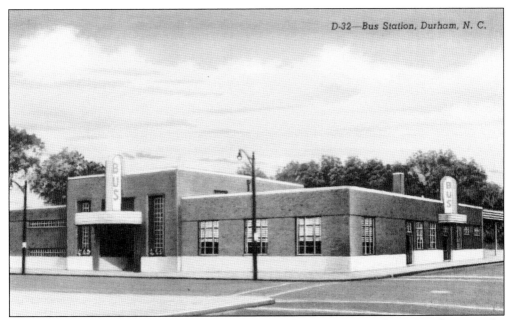

The Durham Union Bus Terminal opened in September 1942 at 411 East Main Street at the corner of Dillard Street. It replaced the old station, which had stood on the corner of Mangum Street and Rigsbee Avenue. The Main Street building, constructed at a cost of $100,000, was the destination of many coach and bus lines until a new station supplanted it in 1986. St. Philips Episcopal church currently owns the property.

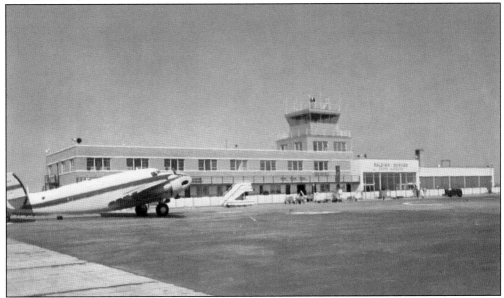

The beginnings of the Raleigh-Durham International Airport can be traced to 1941, when the Durham-Raleigh Aeronautics Authority was authorized to purchase land and construct and operate an airport at a point between the two cities. In 1942 the authority leased the site of the proposed facility to the United States government for use as an air command base during World War II. The airport officially opened in May 1943; after the war it came under civilian control. This early 1960s view shows the main terminal and control tower.

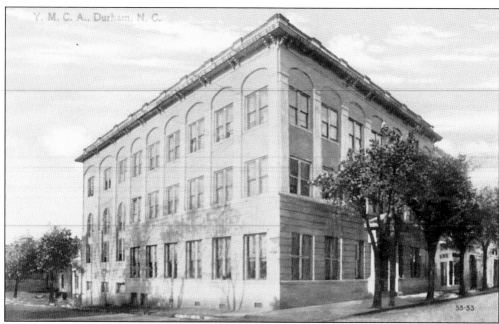

Contributions from George W. Watts (1851–1921) and the Duke family helped boost a fund drive and led to the construction of the YMCA at the southwest corner of Main and Roxboro Streets in 1908. The cost of the three-story building was $35,000. The facility included a swimming pool in the basement and a gymnasium and dormitories on the second and third floors. It was in use until a new building was opened in 1957. Durham County Social Services presently occupies the site.

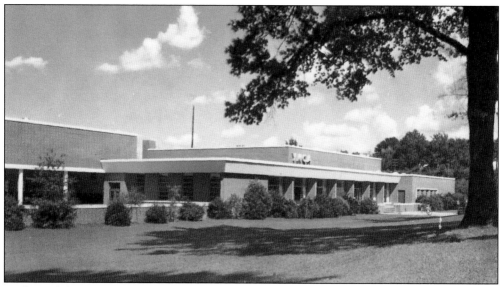

Durham dedicated its new YMCA on Trinity Avenue at Duke Street in 1957. The facility contained a swimming pool connected to a sun deck, as well as a gymnasium, a game room, and offices. The compiler took his first swimming lessons there and participated in numerous church basketball and softball games at the "Y." The building is presently home to the Duke University Diet and Fitness Center, operated by Duke University Medical Center.

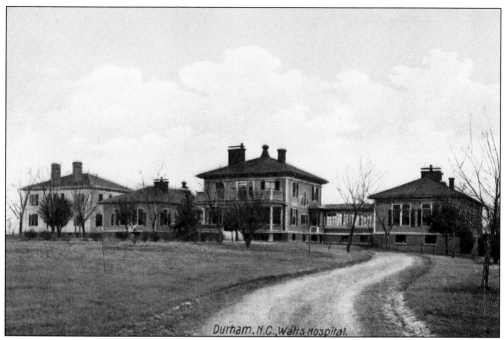

George W. Watts presented this hospital to the citizens of Durham in 1895. It was located on 4 acres of land at the corner of West Main Street and Guess Road (later Buchanan Boulevard). This early 1900s view of Watts Hospital shows its central administration building, flanked by two patient wings—one for men and the other for women.

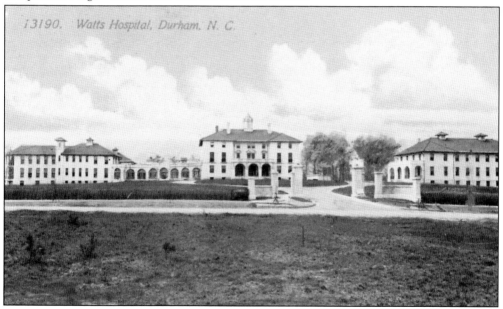

Within ten years, Watts realized that the hospital was not sufficient to meet the growing demands for health care in Durham. He decided to finance a new hospital for the community on a large tract of land off Broad Street. The six-building complex, with stucco exterior and red tile roofs, was of Spanish Mission-style architecture. The half-million-dollar facility opened in December 1909.

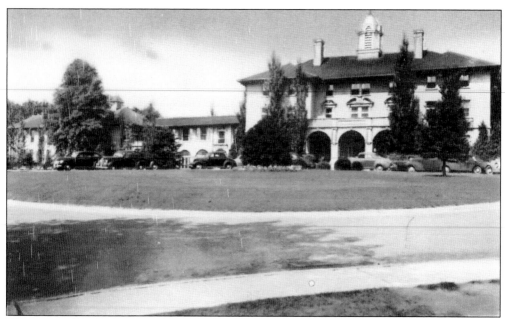

This postcard features a 1940s close-up view of the Watts Hospital main building, crowned with its tall cupola. Many of Durham's baby boomers, including the compiler, were born in the delivery room of the maternity ward on the third floor of this facility. (Courtesy of Willard E. Jones.)

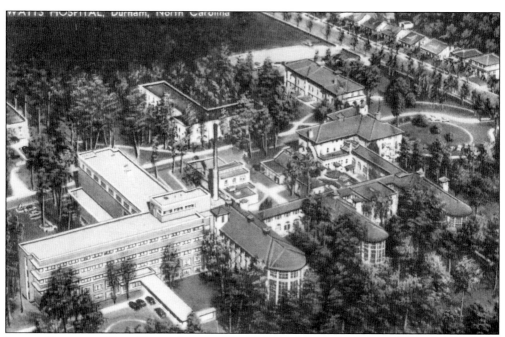

Later additions to Watts Hospital are visible in this aerial photograph made in the 1950s. At that time, the complex included more than three hundred beds. A residential section of Broad Street is visible in the upper-right portion of the picture. Watts Hospital closed in 1976 upon the completion of Durham County General Hospital. The old hospital campus presently houses the North Carolina School of Science and Mathematics.

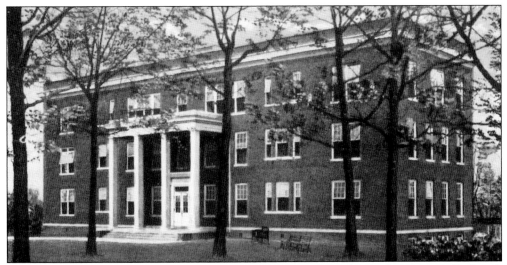

Dr. Aaron M. Moore was largely responsible for the founding of Lincoln Hospital, Durham's first medical care facility for blacks. Initially the hospital was located in a wooden structure built in the early 1900s on Proctor Street. Within a dozen years that building became obsolete, and officials began a drive for a new hospital. George W. Watts and John Sprunt Hill donated land on Fayetteville Street, and the Duke family contributed money for construction, which commenced in 1924. The three-story facility opened the following year. The postcard shows the red brick Colonial Revival-style building as it appeared in the 1930s. Lincoln Community Health Center is now a component of the Durham County Hospital Corporation.

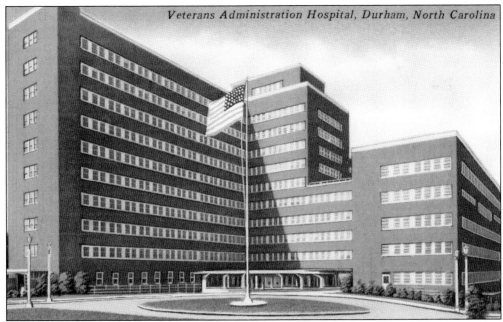

Veterans Administration Hospital, Durham, North Carolina

The federal government announced in 1946 that it would construct a veterans hospital in Durham. Duke University made land on Erwin Road available for the proposed facility. After several delays, the hospital opened in 1953. The Veterans Administration Hospital has been enlarged in subsequent years and is presently known as the Veterans Administration Medical Center.

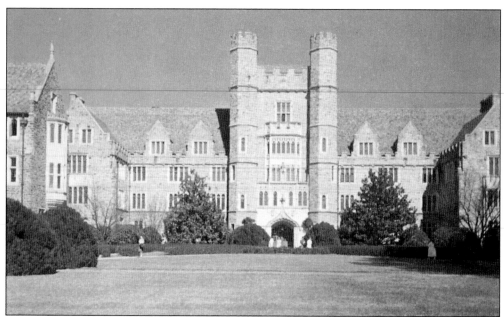

In his will, James B. Duke (1856–1925) set aside $4,000,000 for the construction of medical facilities at Duke University. A four hundred-bed hospital opened on the campus in July 1930. The university launched its medical school in October 1930 with the capacity for accepting three hundred students. This building is named for Wilburt C. Davison (c. 1892–1972), founding dean of the medical school.

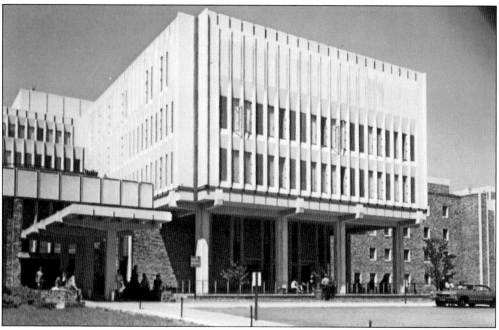

During the following decades Duke University gradually expanded its medical facilities, and by the 1960s Duke Hospital became one of the major medical centers in the Southeast. Duke University Medical Center is now one of the leading teaching, research, and specialized-treatment facilities in the nation and contributes significantly to the economy of Durham.

Three

INDUSTRY

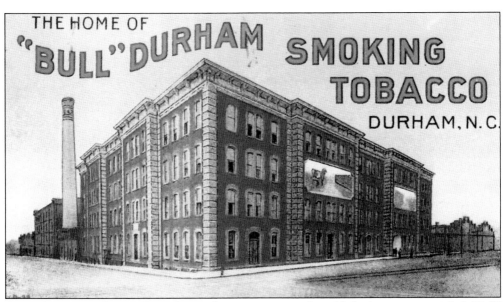

One of a group of more than thirty advertising postcards published in a series titled *"Bull" Durham's Trip Around The World*, this 1910s view depicts the home factory of the giant tobacco-manufacturing firm in Durham. (Courtesy of B.W.C. Roberts.)

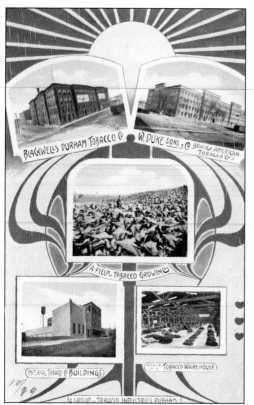

The postcard publisher combined five images to form this composite photograph of the tobacco industry in Durham prior to 1910. Pictured are the three leading tobacco concerns—Blackwell's Durham Tobacco Company, W. Duke, Sons and Company, and the Imperial Tobacco Company. Also included are a tobacco field (center) and an interior photograph of a tobacco-auction warehouse (bottom right).

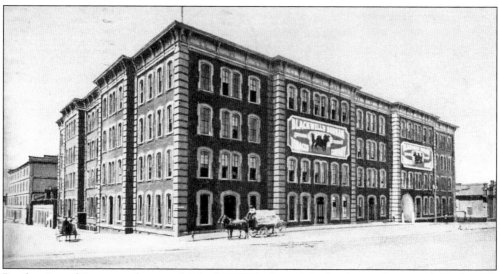

By the time this postcard was published (1909), the original tobacco factory of Blackwell's Durham Tobacco Company had been in operation for nearly thirty-five years. The oldest portion of the elegant Italianate-style edifice had been completed in 1874 south of the tracks of the North Carolina Railroad. This is a street-level view of the structure at the corner of Blackwell and West Pettigrew Streets. The building is still standing, but is partially hidden by a metal facade added during renovations in the 1950s. This important tobacco landmark is listed on the National Register of Historic Places.

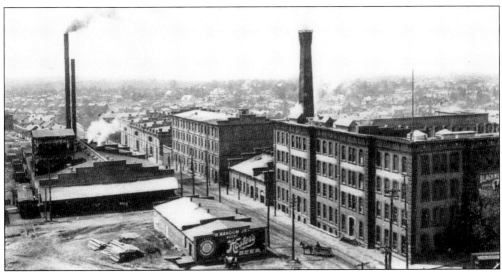

A photographer captured this pre-1910 bird's-eye view of the Blackwell's Durham Tobacco Company complex by pointing his camera southwestward from an upper floor of a downtown building. The image reveals the plant's expansion from the 1874 building southward along Blackwell Street. The American Tobacco Company, successor to the Blackwell firm, closed its Durham branch in 1987. The now-empty buildings are adjacent to the new Durham Bulls Athletic Park, which opened in 1994. (Courtesy of Durwood Barbour.)

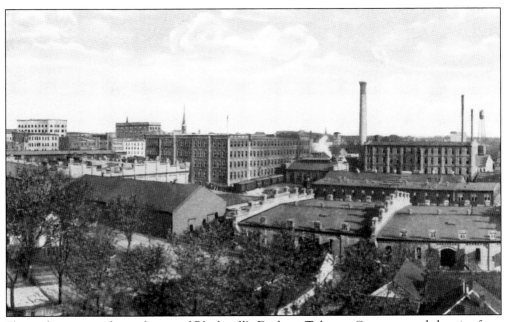

Shown here is an elevated view of Blackwell's Durham Tobacco Company and the city from the southwest as they appeared about 1915. Tobacco-storage warehouses, topped with their unique chimneys, are visible in the foreground. The steeple of Trinity Methodist Church graces the northeastern skyline.

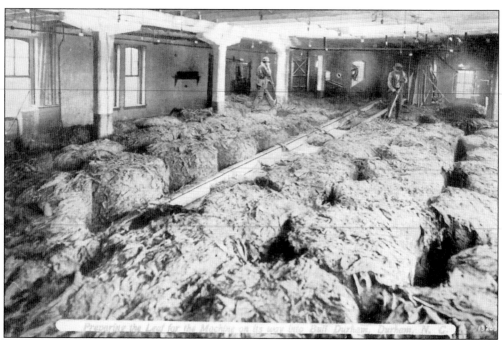

Workmen at Blackwell's factory use pitchforks to load cured tobacco onto a conveyor belt which transported the leaf to machines that manufactured it into Bull Durham Smoking Tobacco. The date of this unusual interior view is about 1914. (Courtesy of B.W.C. Roberts.)

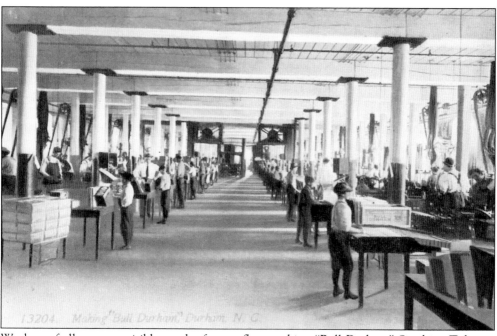

Workers of all ages are visible on the factory floor making "Bull Durham" Smoking Tobacco in this rare interior scene from about 1914. Young boys stand at work tables, where they apparently are packing and boxing the final product for shipment around the world. (Courtesy of B.W.C. Roberts.)

Pictured here are two more advertising postcards from the 1910s set titled *'Bull' Durham's Trip Around The World*. The card to the right portrays a triumphant bull standing at the South Pole with the company's proclamation that its tobacco is "Best From Pole To Pole." (Courtesy of B.W.C. Roberts.)

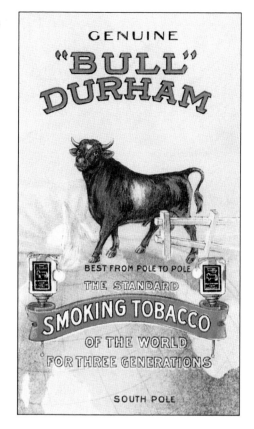

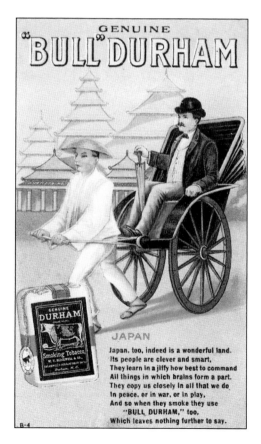

The image to the left suggests that Bull Durham Smoking Tobacco is also the preferred brand in Japan. The company went to great lengths to promote its product throughout the world.

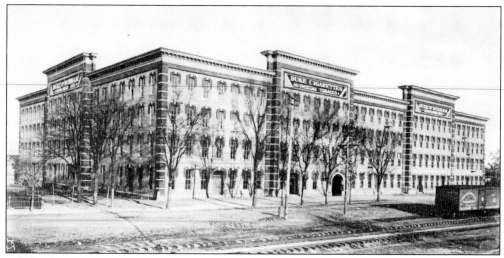

While Blackwell's factory held the upper hand in the manufacture of smoking tobacco, W. Duke, Sons and Company had the lead in cigarette production at the turn of the century. This *c.* 1906 postcard depicts the Duke firm's four-story building, completed in 1884 primarily for the manufacture of cigarettes, from the southwest corner adjacent to the railroad tracks. (Courtesy of Sarah M. Pope.)

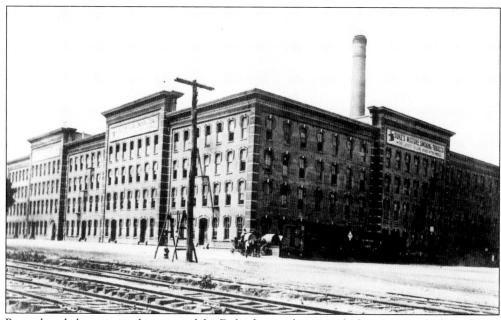

Reproduced above is another view of the Duke factory from a real-photo postcard of the 1910s. This image shows the southern and eastern facades of the structure, which is located near the southeast corner of Main and Duke Streets. The building, which has since been reduced to two floors, is currently a part of the Liggett Group cigarette plant. The compiler's mother made Chesterfield cigarettes in this factory in the 1940s. (Courtesy of Special Collections Library, Duke University.)

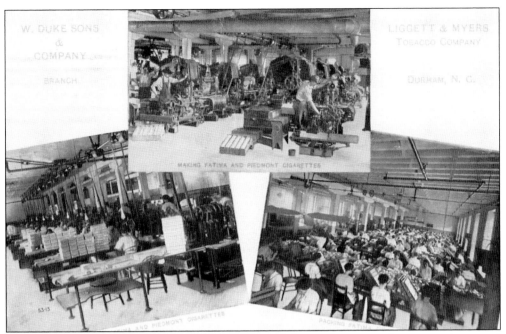

In 1911 the federal courts dissolved the American Tobacco Company, the monopoly created by James B. Duke in 1890, and formed four separate companies. W. Duke, Sons and Company became a branch of the Liggett and Myers Tobacco Company. This World War I-era postcard contains composite interior views of the plant's assembly-line production of Fatima and Piedmont cigarettes, two favorite brands of the day.

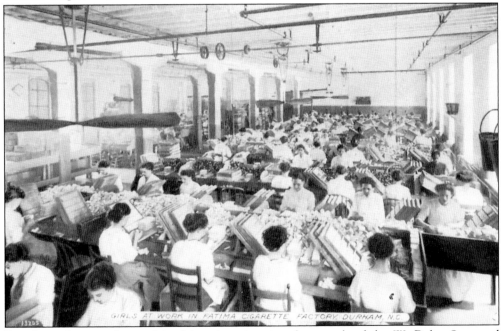

Female workers are featured in this unique interior photograph of the W. Duke, Sons and Company cigarette factory in the 1910s. These women were very skilled at cigarette packing and some are shown stuffing Fatima cigarettes into individual packs.

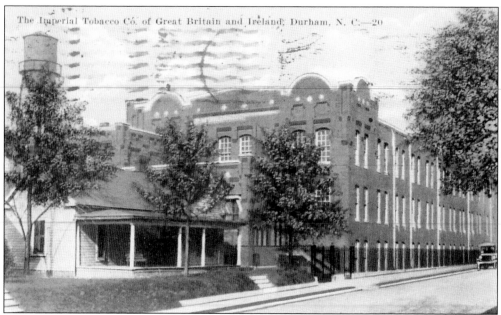

The Imperial Tobacco Company of Great Britain and Ireland, long a competitor of the American Tobacco Company, established a leaf-handling and redrying factory on Morris Street in 1916. The imposing Romanesque-style building, designed by architect C.C. Davis of Richmond, Virginia, is depicted as it appeared in the early 1920s. Imperial Tobacco moved its operations to Wilson, North Carolina, in 1962, and the decorating firm of D.C. May purchased the former Imperial Building in 1965.

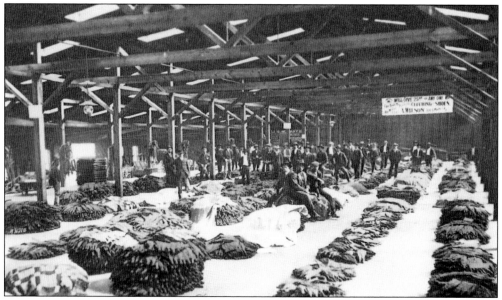

An important component of the tobacco industry in Durham was the loose-leaf auction warehouse. The first auction sale in Durham occurred in 1871, and soon thereafter the town gained a thriving warehouse business. This 1907 interior view of an unidentified warehouse floor shows buyers standing amid rows of cured tobacco during an auction sale. At that time, the Banner, Planters, and Parrish Warehouses were operating in Durham.

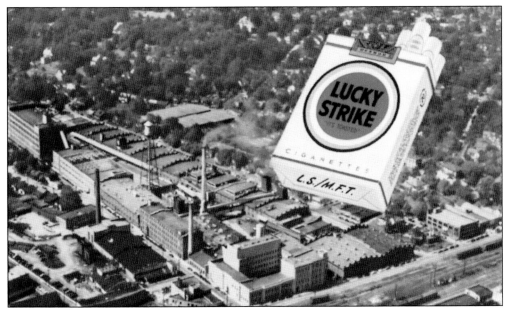

An aerial view from about 1960 shows the sprawling operation of the American Tobacco Company in Durham. Superimposed on the photograph is a pack of Lucky Strike cigarettes, the company's most famous brand.

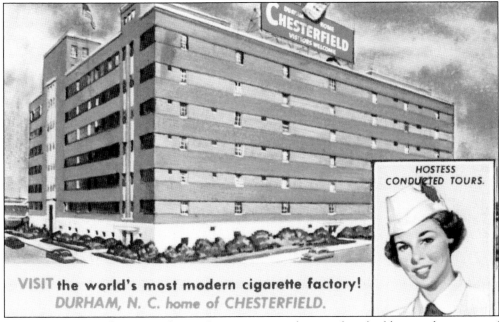

VISIT the world's most modern cigarette factory!
DURHAM, N. C. home of CHESTERFIELD.

HOSTESS CONDUCTED TOURS.

In 1948 Liggett and Myers Tobacco Company opened its modern building at the corner of Main and Duke Streets. The facility is dedicated to "The Millions Who Smoke the Cigarette that Satisfies, Chesterfield." The sender of this card purchased it in 1958 when she toured the cigarette plant.

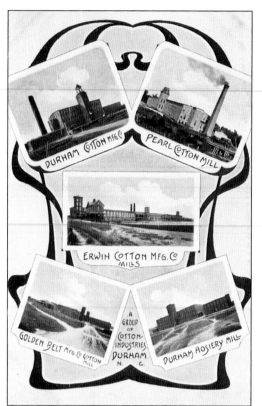

Financed with profits from the tobacco industry, textile-manufacturing enterprises sprang up in Durham about the turn of the century. This postcard includes a grouping of the most successful "cotton industries" in the city between 1905 and 1910. At that time, Durham had four cotton mills, two hosiery mills, and one bag mill.

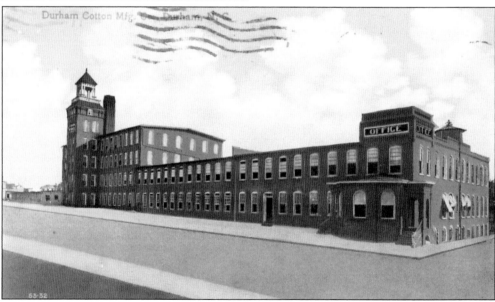

Julian S. Carr (1845–1924) was the driving force behind the establishment of Durham Cotton Manufacturing Company in 1884. This firm first made cloth for tobacco bags, but later produced chambrays, ginghams, and colored goods. The town of East Durham developed around this enterprise, which was the city's first textile mill. Shown here is an exterior view of the building on East Pettigrew Street about 1913. (Courtesy of Willard E. Jones.)

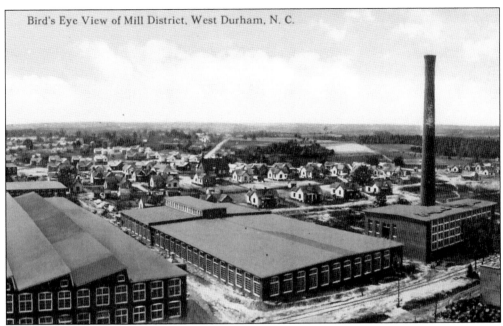

Bird's Eye View of Mill District, West Durham, N. C.

Benjamin N. Duke (1855–1929) established Erwin Cotton Mills and named William A. Erwin (1856–1932) to manage the operation, which opened on land west of Trinity College in 1893. The factory initially produced muslin for tobacco bags but later manufactured denims. This elevated view shows the mill after its expansion in 1910. In the distance is the mill village that developed around the enterprise and helped create West Durham, a community that at one time had a population of five thousand.

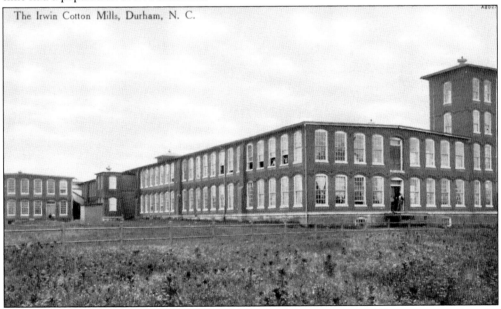

The Irwin Cotton Mills, Durham, N. C.

Reproduced here is a ground-level view of a portion of Erwin Cotton Mills as it appeared in the 1910s. The textile giant, located near the intersection of West Main and Ninth Streets, became one of the largest producers of denim in the nation. The compiler's maternal grandfather moved from Salisbury, North Carolina, in 1912 to work at the mill. The operation closed in 1986.

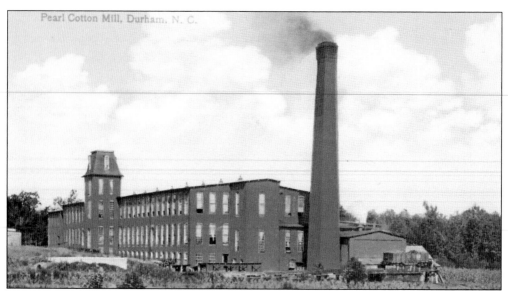

Brodie L. Duke (1846–1919) launched the Pearl Cotton Mill in 1893 on property adjacent to what would become West Trinity Avenue near Duke Street. Shortly thereafter, other members of the Duke family and George W. Watts purchased the mill, and it proved to be highly successful in the making of extra-wide sheeting. William A. Erwin and his brother J. Harper Erwin (1864–1962) supervised the concern, which in 1932 became part of Erwin Mills. The firm ceased operations in the 1950s, and all was demolished except for the mill tower and smokestack. The site later became the home of Duke Tower Apartments and subsequently the Duke Tower Residential Suites.

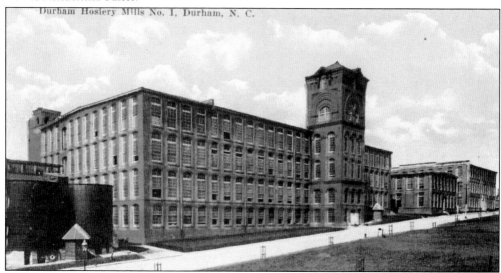

Julian S. Carr used profits from the tobacco industry to start Durham Hosiery Mills in the late nineteenth century. The venture was prosperous under the direction of his son, Julian S. Carr Jr. (1876–1922), and the structure pictured here was completed in 1902. At one time the Angier Avenue building, in the Edgemont section of East Durham, was the center of the largest hosiery mill complex in the world. The compiler's paternal grandfather left a farm in Johnston County, North Carolina, in 1921 for a job at the mill. A portion of the complex has been renovated and is presently home to the Durham Hosiery Mill Apartments.

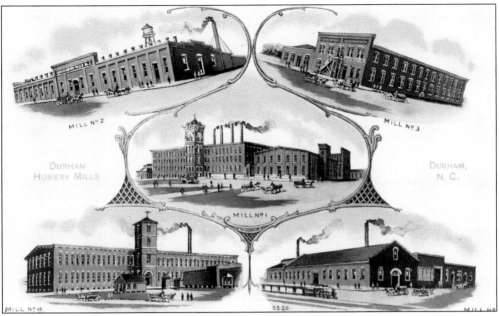

In the early 1910s Durham Hosiery Mills expanded to other North Carolina cities. This collage features the original mill in Durham, surrounded by four additional textile facilities. Mill No. 2, also located in Durham, was the first textile mill in the United States to be operated exclusively by black labor. Mills No. 3, 4, and 5 were located in High Point, Chapel Hill, and Goldsboro respectively. (Courtesy of Betsy M. Holloway.)

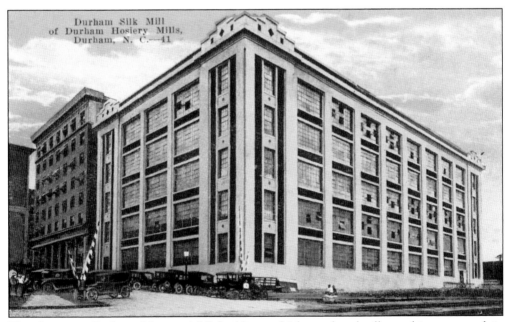

The five-story Durham Hosiery Mill building, which produced silk stockings, opened in December 1919 on Corcoran Street, adjacent to the First National Bank. The business prospered for about five decades before closing in February 1969. The company transferred the operation to Franklinton, North Carolina, and this well-constructed edifice was torn down in 1970.

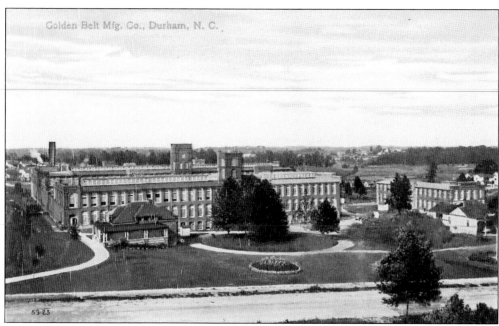

Golden Belt Mfg. Co., Durham, N. C.

The Golden Belt Manufacturing Company had its beginnings in 1887 as a bag-making venture at Blackwell's Durham Tobacco Company. In 1902 Julian S. Carr moved the company to the more commodious facilities depicted on this postcard. The new plant, located off East Main Street in the Edgemont section just north of Durham Hosiery Mills, consisted of a bag factory and a cotton mill. By 1910 the firm employed eight hundred workers. After the textile operations ceased, the establishment produced packaging for the American Tobacco Company. Golden Belt Manufacturing Company closed in December 1996.

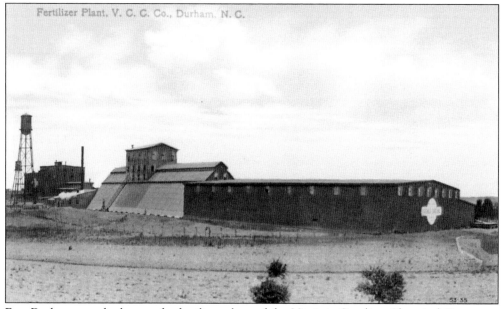

Fertilizer Plant, V. C. C. Co., Durham. N. C.

East Durham was the home of a fertilizer plant of the Virginia-Carolina Chemical Company. The factory was erected in 1906 on Raleigh Road (later Angier Avenue). The annual output of the concern was twenty thousand tons of fertilizer.

Four

A ROOF OVER THEIR HEADS

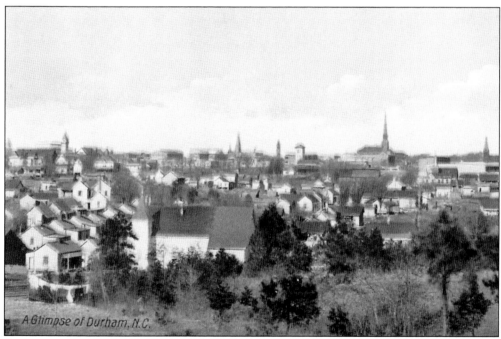

A photographer captured this cityscape from the crest of a hill in southern Durham, near the Hayti section. The *c.* 1906 view includes a large residential area, as well as the tops of many distant landmarks such as the Hotel Carrolina, Union Station, and Trinity Methodist Church.

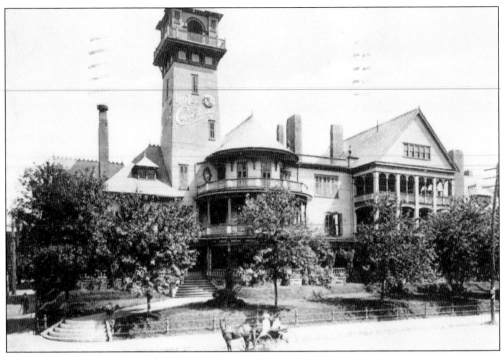

The Hotel Carrolina was one of the finest hostelries in the South. Julian S. Carr built the elegant seventy-room structure in 1891 at the terminus of South Corcoran Street at the railroad tracks. The hotel stood on the former property of Dr. Bartlett L. Durham (1824–1859), from whom the city received its name. Its central location, numerous piazzas, and ornately decorated rooms were special attractions for the guests. A fire destroyed the hostelry in May 1907.

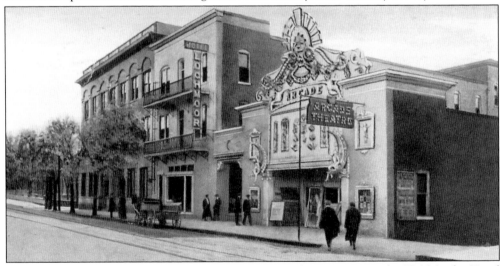

Shown left to right in this view of Main Street near Roxboro Street are the YMCA, the Hotel Lochmoor, and the Arcade Theater. Edward J. Parrish (1846–1920) constructed the hotel, initially named the Arcade, in 1911 to fill the need for accommodations that arose after the destruction of the Hotel Carrolina in May 1907. The Lochmoor was not able to compete with the newly constructed Hotel Malbourne across the street and closed in 1914. (Courtesy of Betsy M. Holloway.)

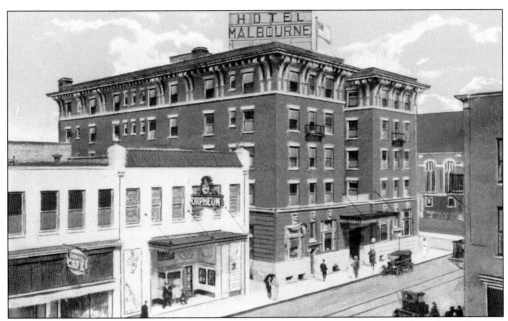

The Hotel Malbourne opened in 1913 on the northwest corner of Main and Roxboro Streets. It received its name in honor of Benjamin N. Duke's father-in-law, Malbourne A. Angier (1820–1900). The structure boasted one hundred and twenty-five rooms with all the modern conveniences. Adjacent to the hotel in this c. 1920 view are the Orpheum Theater and the Durham Café.

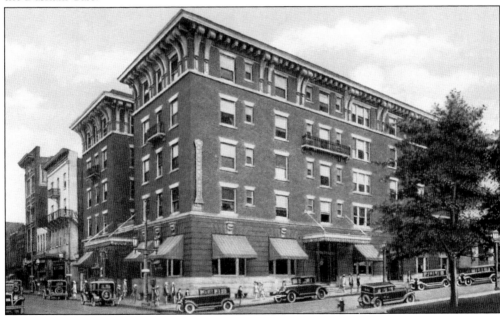

Under the operation of Everitt I. Bugg (1885–1957), the Malbourne remained popular with the traveling public for more than four decades. By the 1930s it had expanded to two hundred fireproof rooms, which could be rented for $1.50 to $3.00 a night. The hotel was a favorite among soldiers stationed at Camp Butner during World War II. It closed in 1966 and was torn down to make way for the Durham County Judicial Building.

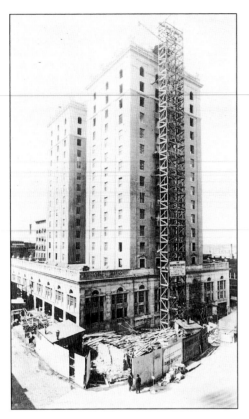

Opened in 1925, the Washington Duke Hotel supplanted the Hotel Malbourne as Durham's finest public accommodation. This rare real-photo postcard shows the sixteen-story building shortly before its completion. The structure occupied the site of the former Municipal Building and Academy of Music, bound by Corcoran, Parrish, Market, and Chapel Hill Streets. With a price tag of $1.8 million, it was considered to be the finest hotel in the South in the 1920s.

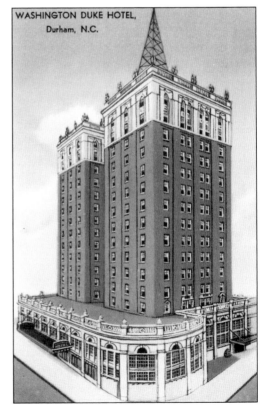

In 1960 the Washington Duke Hotel became a part of the Jack Tar chain. It bore the name Jack Tar Hotel Durham until 1969, when it was renamed the Durham Hotel. The facility closed in August 1975 and was imploded on Sunday morning, December 14, 1975. The compiler, accompanied by his father and a cousin, witnessed the sad event and recorded it with a super-8 movie camera. The site is now a parking lot.

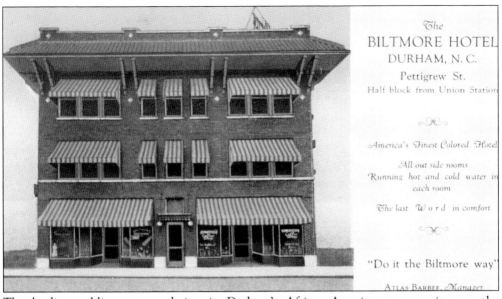

The leading public accommodation in Durham's African-American community was the Biltmore Hotel on East Pettigrew Street. Dubbed "America's Finest Colored Hotel," the three-story structure was situated one-half block from Union Station. The building also included a drugstore and coffee shop on the ground floor. The Biltmore fell victim to the wrecking ball during urban renewal in the 1960s or 1970s. (Courtesy of Durwood Barbour.)

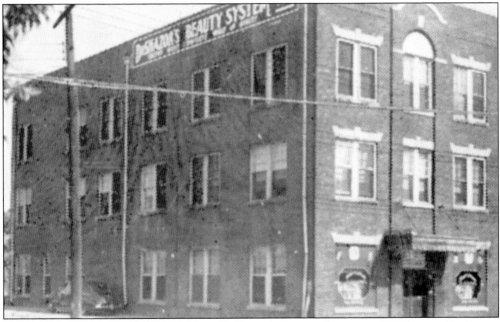

Another important black enterprise was DeShazor's Beauty System at 809 Fayetteville Street. Jacqueline DeShazor Jackson (1908–1984), a native of Troy, Alabama, operated the three-story business, which also included room rentals, from 1937 to the 1960s. The hostelry was advertised as a "Travelodge of Distinction." The firm offered a beauty college and supplies, and it was known as "America's Most Complete House of Service, Beauty and Charm." (Courtesy of Betsy M. Holloway.)

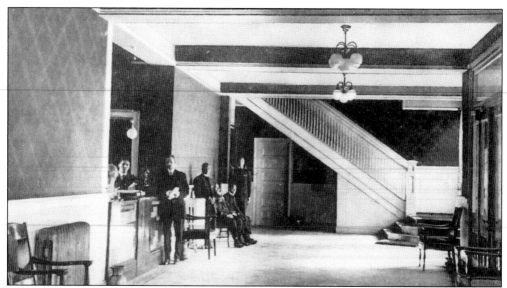

Clerks and porters pose for the camera in this interior view of the Corcoran Hotel made soon after the new facility opened on East Chapel Hill Street in 1907, shortly after a disastrous fire had destroyed the Hotel Carrolina. Stiff competition from the Hotel Malbourne forced the Corcoran to close its doors in 1914, and afterward the structure was home to Mercy Hospital for several years. About 1919 the Durham Business School moved into the building. The Center Theater and Home Savings and Loan Association later occupied the site. (Courtesy of Willard E. Jones.)

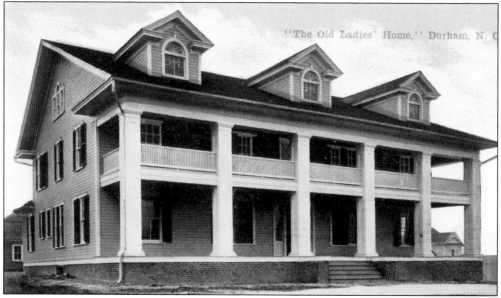

The International Order of the King's Daughters and Sons is an interdenominational association of Christian men and women. The Durham circle of the organization opened in 1903 and constructed this "Old Ladies Home" on Buchanan Boulevard at the corner of Gloria Avenue in 1911. Brodie L. Duke donated the land and $500 for the two-story home for aged women. Its capacity of twelve residents soon became inadequate, and the order replaced it with the present building in 1925. (Courtesy of Betsy M. Holloway.)

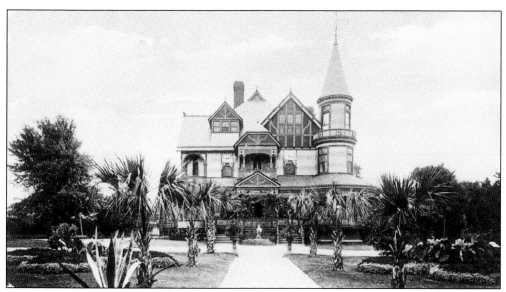

"Somerset Villa," the mansion of Julian S. Carr, is shown as it appeared about 1905. Completed in 1888, the seventeen-room, ten-bath Victorian dwelling was situated on 4 acres bound by Main, Dillard, and Peabody Streets. Carr spent $125,000 for the construction and landscaping of his residence. Shortly after Carr's death in 1924, the structure was razed, and the materials were reused in the construction of three houses in the 1000 block of Green Street. (Courtesy of Willard E. Jones.)

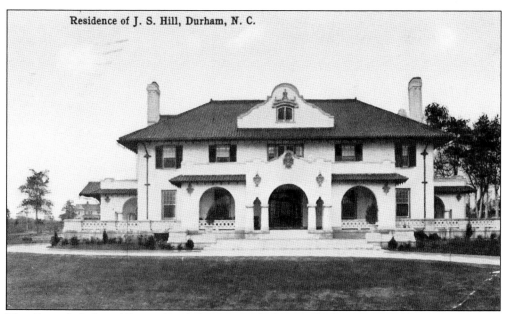

This Spanish Colonial Revival-style house was the home of John Sprunt Hill, one of Durham's leading businessmen and capitalists. The Boston firm of Kendall and Taylor designed the mansion, which was completed on South Duke Street in 1911. Hill married Annie Louise Watts (1876–1940), the only child of George W. Watts. Following her death, Hill created the Annie Watts Hill Foundation, which makes the dwelling available for women's organizations. The Junior League of Durham presently uses the residence as its headquarters.

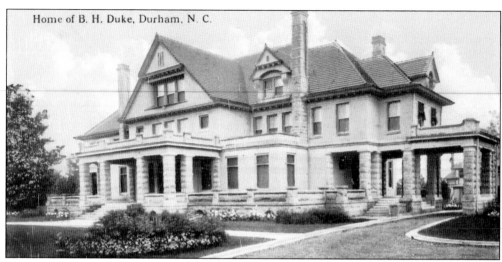

Home of B. H. Duke, Durham, N. C.

Completed about 1910 at a cost of $136,000, "Four Acres" was the second home in Durham of Benjamin N. and Sarah Pearson Angier Duke (1856–1936). The caption on the postcard erroneously included an H for Benjamin Duke's middle name. The Chateauesque Revival-style mansion was located on the southeast corner of Chapel Hill and Duke Streets. Following the deaths of the couple, Duke University acquired the dwelling and utilized it as a guesthouse and reception center. In 1960 the university sold the property, and the home was demolished. North Carolina Mutual Life Insurance Company erected its headquarters building on the site in 1966.

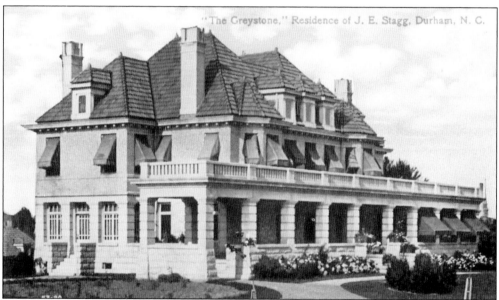

"The Greystone," Residence of J. E. Stagg, Durham, N. C.

In 1911 James E. Stagg (1860–1915) and his wife, Mary Washington Lyon Stagg, moved into "Greystone," their Chateauesque-style mansion on Morehead Street. The Charlotte architect C.C. Hook designed the residence. Stagg was related to the Duke family on his father's side, and his mother was the sister of Dr. Bartlett L. Durham. Stagg's wife was the granddaughter of Washington Duke (1820–1905). Stagg, a shrewd businessman, worked as a railroad, banking, and textile executive. In 1961 the massive house was divided into apartments and offices. (Courtesy of Sarah M. Pope.)

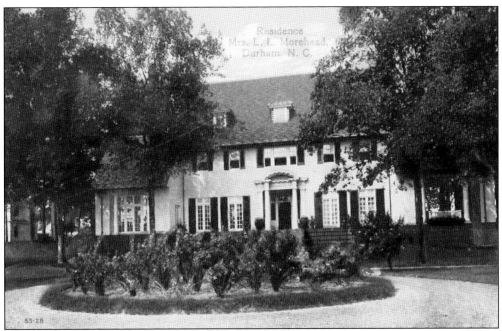

Shown here, in a postcard view before 1910, is the residence of Mrs. Lucy Lathrop Morehead (1851–1918). It was located in the Morehead Hill neighborhood, just southwest of the city. The Queen Anne- and Stick-style home was built in the early 1880s for Mrs. Morehead and her husband, Eugene L. Morehead (1845–1889), banker, industrialist, and son of North Carolina governor John Motley Morehead. The dwelling is no longer standing.

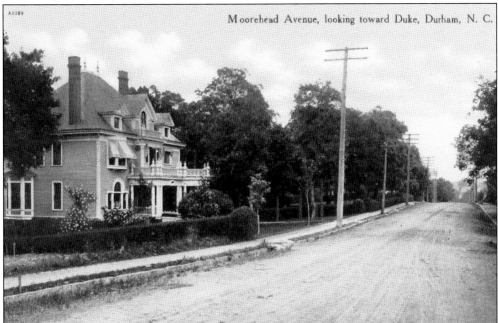

About 1910 a cameraman looking east toward Duke Street made this photograph of an unpaved Morehead Avenue. At left is one of the fashionable homes in the Morehead Hill neighborhood, where many of the industrialists and financiers of Durham resided at the turn of the century.

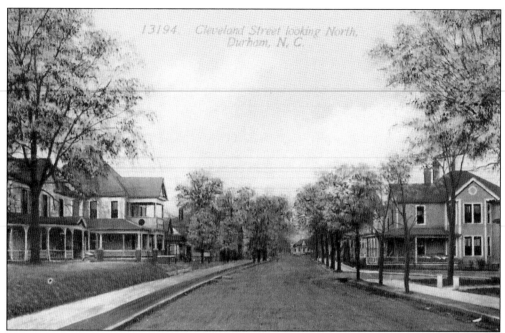

This postcard offers a glimpse of Cleveland Street, looking north, in the early 1910s. The avenue was located just northeast of the city and was one of Durham's earliest and most stylish residential neighborhoods. On the left are the Howerton-Masser House (1890s) and the Freeland-Markham House (early 1900s), which are still standing.

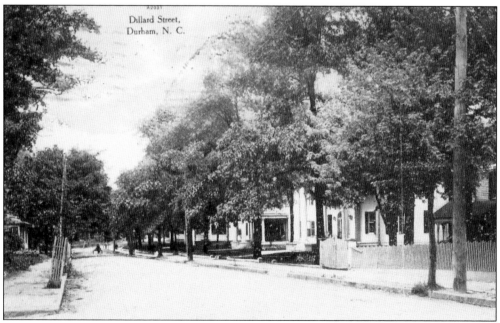

A photographer captured the tree-lined appearance of Dillard Street, looking north from the corner of Liberty Street, in this card postmarked 1910. Often referred to as "Mansion Row," Dillard Street was the home of many of Durham's tobacco and textile magnates at the beginning of the twentieth century.

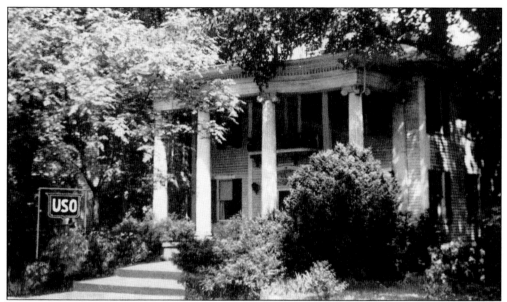

The two-story Colonial Revival-style house at 206 North Dillard Street is the Charlie C. Thomas House, which was constructed in 1909. Thomas (1870–1931) founded Thomas and Howard, a wholesale grocery business. After his death, the house became one of Durham's USO recreation centers for servicemen during World War II. Subsequently, the house was divided into apartments, but currently it is a private residence. (Courtesy of Betsy M. Holloway.)

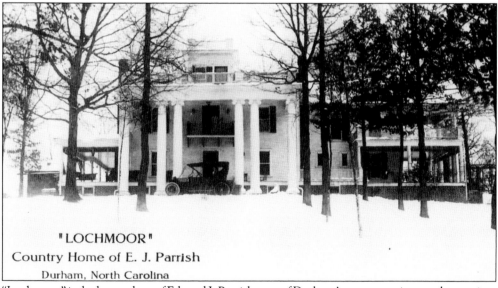

"LOCHMOOR"
Country Home of E. J. Parrish
Durham, North Carolina

"Lochmoor" is the homeplace of Edward J. Parrish, one of Durham's most prominent tobacconists. Parrish moved to Durham in 1871 and established himself as a successful tobacco warehouseman. As a representative of the American Tobacco Company at the turn of the century, he traveled to the Far East. Parrish returned to North Carolina about 1904 and lived out the remainder of his years at Lochmoor. This real-photo postcard shows the dwelling with a wintry covering of snow in the 1910s. The house, which used to stand on North Roxboro Road near the Eno River, has been torn down. (Courtesy of Special Collections Library, Duke University.)

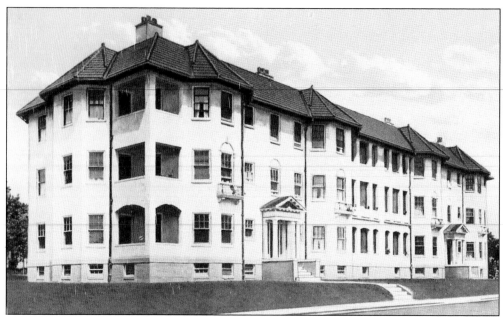

Durham's first apartment complex, the Beverly Apartments, opened in 1913 at the northwest corner of Main and Watts Streets. The endowment fund of Watts Hospital owned the building, which contained ten five-room apartments. The apartments have since been demolished.

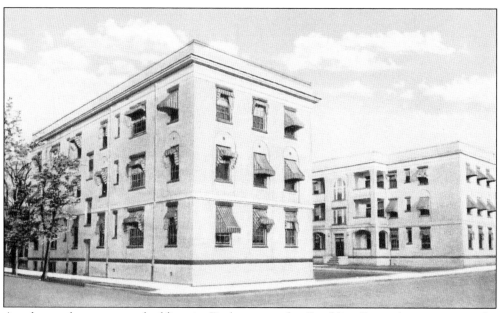

Another early apartment building in Durham was the Franklin Court Apartments at the northeast corner of Main and Dillard Streets. The World War I-era building was torn down in the early 1970s and replaced by a low-income housing complex for the elderly, presently known as the Senior Citizens Memorial Center.

Five

BUSINESS

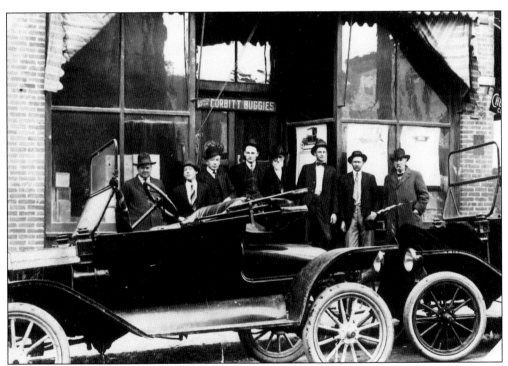

The first automobile came to Durham in 1901, and by 1907 cars were common in the city. The Carpenter family operated the first Ford dealership at the southwest corner of Church and Parrish Streets in the early 1910s. Among the men shown here in front of the business are several members of the Carpenter family. The older, bearded man standing in the doorway is Duane Carpenter (1846–1921), flanked by his sons, James E. (1870–1938) on the left and J.W. Carpenter. The concern also sold the popular Corbitt Buggies, manufactured in Henderson, North Carolina. (Courtesy of Special Collections Library, Duke University.)

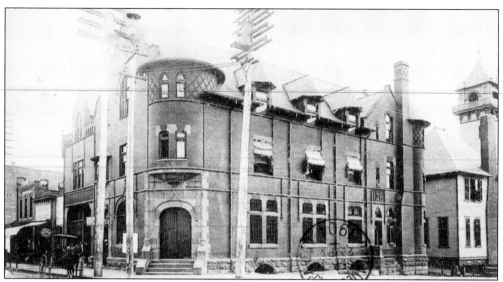

This Queen Anne-style building at the southeast corner of Main and Corcoran Streets was the First National Bank. Julian S. Carr organized the bank and constructed the two-and-one-half-story edifice in 1887. This card, postmarked in 1904, depicts the bank and the tower of the adjacent Hotel Carrolina. (Courtesy of Durwood Barbour.)

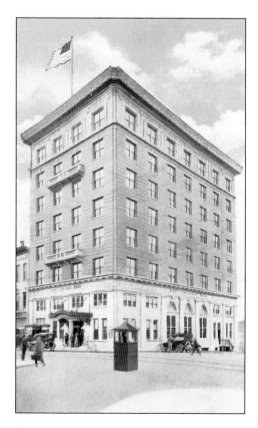

By 1910 the bank needed larger accommodations, and the 1887 building was demolished and replaced by this eight-story structure in 1915. The architectural firm of Milburn and Heister designed the Neoclassical Revival-style edifice. For many years the building housed the North Carolina National Bank. The Durham branch of NationsBank currently occupies the building. (Courtesy of North Carolina Division of Archives and History.)

Here is a postcard view of the Loan and Trust Building prior to 1910. At the time of its construction in 1905, the six-story edifice held the distinction of being the tallest office building in the state. Two of its major tenants were the Fidelity Bank and (later) the Home Savings Bank. The Neoclassical Revival-style structure at 212 West Main Street is still in use. (Courtesy of B.W.C. Roberts.)

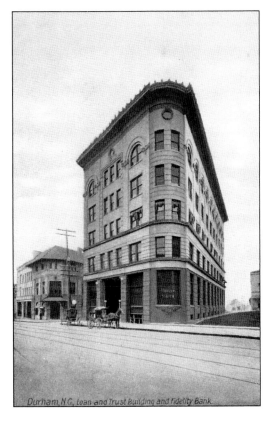

Durham, N.C., Loan and Trust Building and Fidelity Bank.

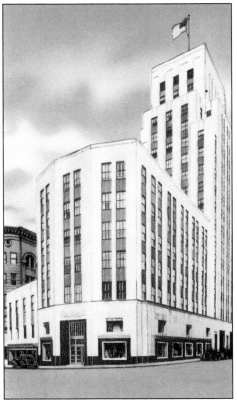

Durham's most prominent architectural landmark is the seventeen-story Hill Building at the northwest corner of Main and Corcoran Streets. It was built between 1935 and 1937 on the site of the old post office. John Sprunt Hill financed the erection of the skyscraper, which was patterned after the Empire State Building, to accommodate his business and banking interests. The building, the one-time home office of Home Security Life Insurance Company, now serves as headquarters of CCB Financial Corporation.

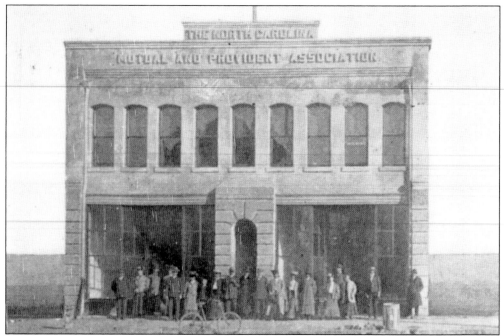

In 1898 John Merrick (1859–1919), Dr. Aaron M. Moore, and other black leaders formed the North Carolina Mutual and Provident Association, Durham's first black-owned insurance company. In 1905 the firm erected its initial office building on Parrish Street. In this postcard scene, a group of Durham citizens proudly stands in front of the newly constructed quarters. The structure was demolished in 1920 and replaced by a larger office.

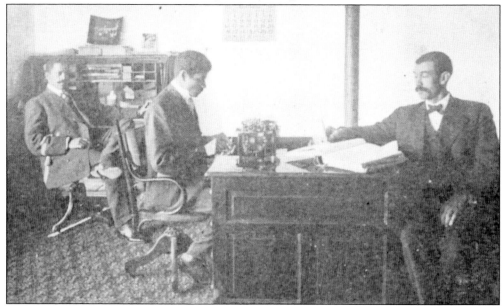

In this rare interior view, the leaders of the North Carolina Mutual and Provident Association pose in the president's office about 1906. Shown left to right are John Merrick, president; Charles Clinton Spaulding (1874–1952), general manager; and Dr. Aaron M. Moore, secretary-treasurer. (Courtesy of Willard E. Jones.)

The growing black insurance company purchased additional lots on Parrish Street for increased office space. Other black businesses, including the Mechanics and Farmers Bank, evolved. The bank, chartered in 1907, shared this six-story building (completed in 1921) on Parrish Street with the insurance company, which in 1919 became known as the North Carolina Mutual Life Insurance Company. Parrish Street came to be known as the "Black Wall Street of America." When the insurance firm moved to its new quarters on West Chapel Hill Street in 1966, this building was renamed the Mechanics and Farmers Bank Building. The National Park Service has designated the structure a National Historic Landmark.

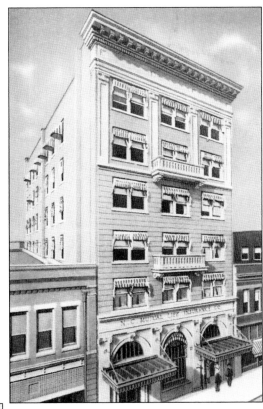

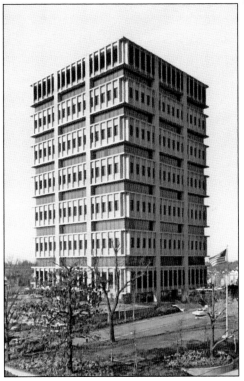

Shown here is a c. 1970 view of the headquarters building of the North Carolina Mutual Life Insurance Company at the corner of West Chapel Hill and Duke Streets. Groundbreaking ceremonies were held in 1963, and Vice-President Hubert H. Humphrey participated in the formal dedication of the building on April 2, 1966. The ten-story structure, designed by the internationally known architectural firm of Welton Becket and Associates, stands on the former site of Benjamin N. Duke's mansion "Four Acres." The headquarters is one of the largest African-American-managed businesses in the world and is situated on the highest point in downtown Durham.

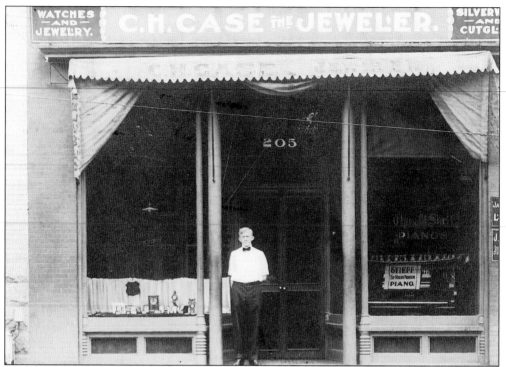

Carl H. Case stands at the entrance to his jewelry store at 205 East Main Street in 1911. He succeeded R.D. Whitley at that location. On the reverse side of the postcard, a handwritten message to Case's father in Jefferson, Ohio, reads: "This is a view of my place."

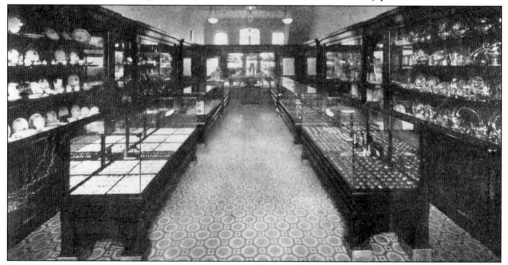

A photographer stepped inside the Jones and Frasier Company jewelry store about 1915 to capture this interior view. M.H. Jones (1845–1913) had founded the firm in 1885 and was joined by partner William G. Frasier Sr. (1878–1937) in 1902. The store stood on West Main Street and was a prosperous business until the 1960s. In the mid-1960s the company opened a second store at Northgate Shopping Center. Subsequently, the downtown store closed, and after a few more years at Northgate, the firm shut its doors for good about 1975. (Courtesy of Betsy M. Holloway.)

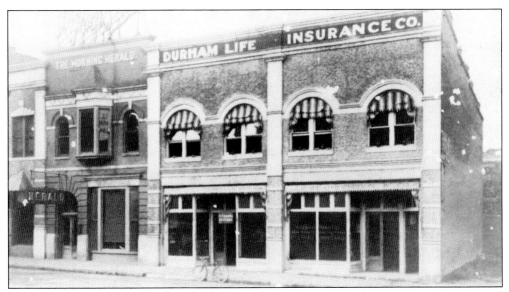

This real-photo postcard from the 1910s includes a view of the buildings housing the *Morning Herald* newspaper and the Durham Life Insurance Company. The *Morning Herald* began publication in 1894 and moved to this Market Street site in 1905. The newspaper purchased the insurance building in 1920 when Durham Life Insurance Company moved to Raleigh. In 1929 the *Herald* acquired the Durham *Sun* and the following year replaced these structures with the Herald-Sun Building, which still stands at 115 Market Street. (Courtesy of Leigh H. Gunn.)

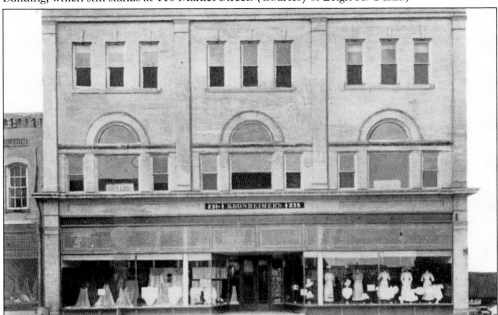

Kronheimer's Department Store was a fixture on West Main Street during the first quarter of the twentieth century. This street-level view was taken about 1913. Owner Benjamin Franklin Kronheimer (1858–1938) used his earnings to construct a beautiful home on Minerva Avenue in 1930. The Neoclassical Revival-style commercial building still stands at 315 West Main Street and in 1993 received an architectural conservation award from the Durham Historic Preservation Society. (Courtesy of Betsy M. Holloway.)

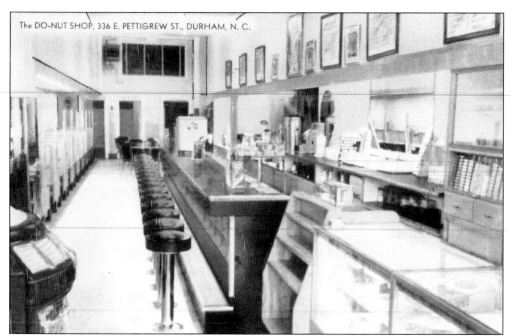

This linen-era postcard includes an interior photograph of the Do-Nut Shop at 336 East Pettigrew Street. The restaurant served the African-American public in the Hayti section for nearly twenty years before it closed about 1960. The eatery was situated on the first floor of a three-story building that stood adjacent to the Regal Theater and two doors down from the Biltmore Hotel. The structure was torn down about 1977. (Courtesy of Durwood Barbour.)

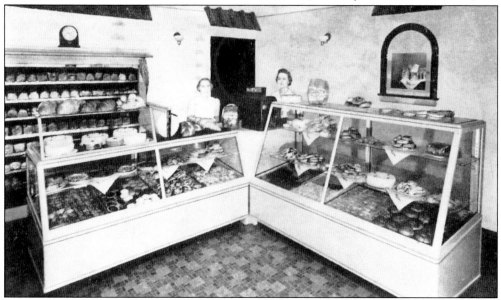

The subject of this postcard is an unusual interior view of the Rolling Pin Bakery and Pastry Shop. Opened about 1939 at 503 West Morgan Street, the establishment sold baked goods at this location until the 1950s. The business was affiliated with the Broadway Sandwich Company. The popular bakery also operated a second store on Broad Street. (Courtesy of B.W.C. Roberts.)

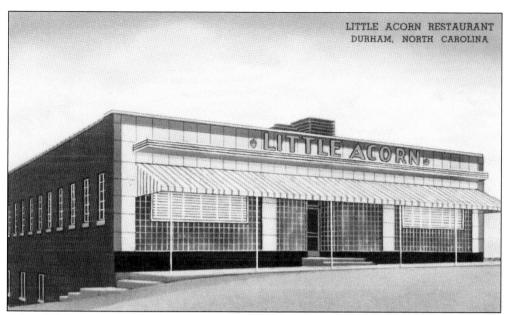

Robert W. Roycroft (1918–1972) established the Little Acorn Restaurant in 1940 on Rigsbee Avenue. This 1940s linen postcard pictures the one-story facility, which featured a menu of barbecue, Brunswick stew, fried chicken, steaks, and seafood. The restaurant was located near the tobacco warehouse district and became a favorite eating house in Durham. (Courtesy of B.W.C. Roberts.)

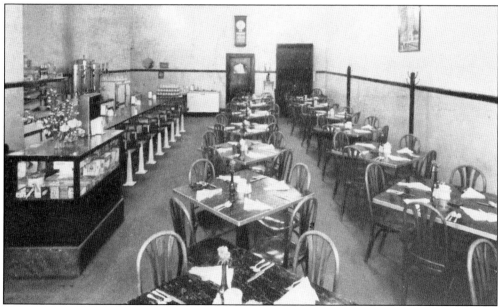

The tables are set and ready for customers in this interior view of the Palms Restaurant about 1939. The popular eatery, at 305 East Chapel Hill Street, was an institution in Durham from about 1920 until it closed in 1983. An early proprietor of the establishment was Norman O. Reeves, who served sizzling steaks and claimed "we never close." The Palms was frequented by downtown employees (lawyers had their own table) and was dubbed the "belly button of Durham."

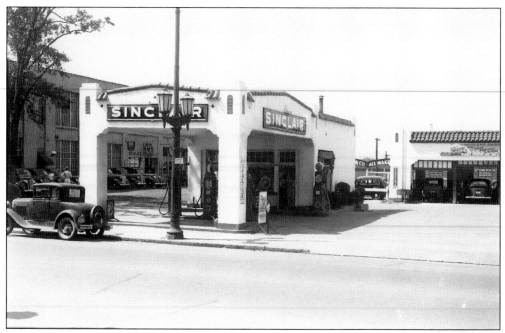

This 1930s real-photo postcard depicts Johnson Service Station, a Sinclair Oil dealership, at 320 East Main Street. To the left of the station is Johnson Motor Company, a successful Buick and Pontiac dealership for many years. The Durham County Sheriff's Detention Services Administration presently occupies the old auto company building. The service station is no longer standing.

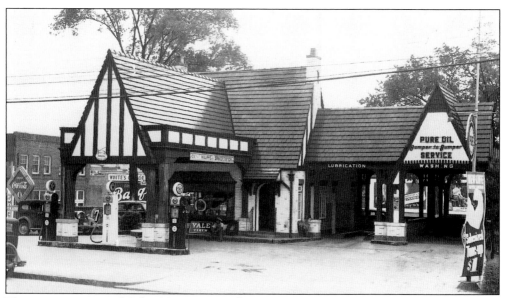

The service station of Caley V. "Mutt" Williams was located at 421 North Mangum Street. The Pure Oil affiliate offered a full array of service for automobiles, including a tune-up for $1 in the late 1930s.

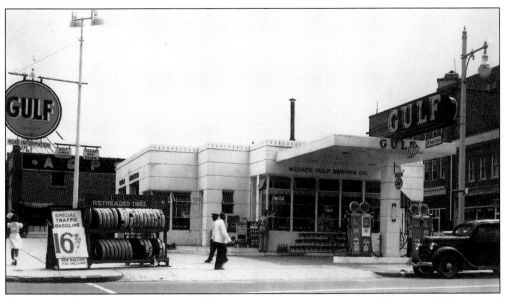

W. Lacy McDade operated this Gulf Oil service station at the corner of Chapel Hill Street and Rigsbee Avenue in the 1930s. The price of gasoline at that time was 16.9¢ a gallon. Behind the station is the A&P grocery store on Rigsbee Avenue. The station has been demolished.

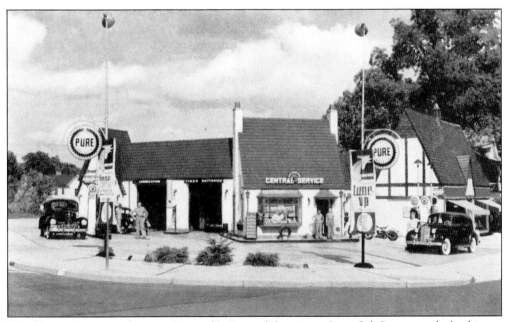

Gasoline station attendants at Roycroft's Central Service, a Pure Oil Company dealership on West Main Street at Watts Street, pose for the cameraman about 1940. The business offered Purol products, Yale tires, and Delco batteries. A convenience store presently occupies the site. (Courtesy of Durwood Barbour.)

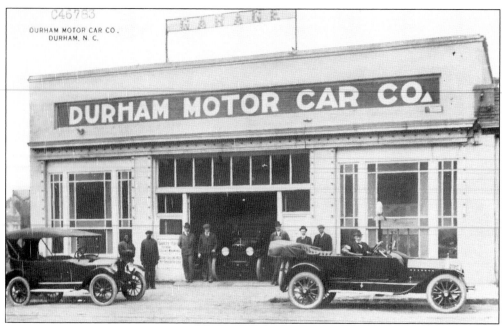

Along with the automobile came the need for repair services. One of the early garages in the city was Durham Motor Car Company. Located on Orange Street, the enterprise served the community from the 1910s to 1940. The business was known as Durham Motor Company Storage and Repair prior to its closing. (Courtesy of Betsy M. Holloway.)

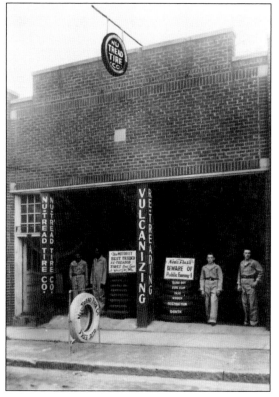

This advertising postcard for Nu-Tread Tire Company was postmarked in August 1939. The business, located at 311 McMannen Street, offered the motoring public a host of tire-related services, including its specialty—retreading. S. Coley Ray purchased the company in 1943 and four years later moved it to its present location on Foster Street.

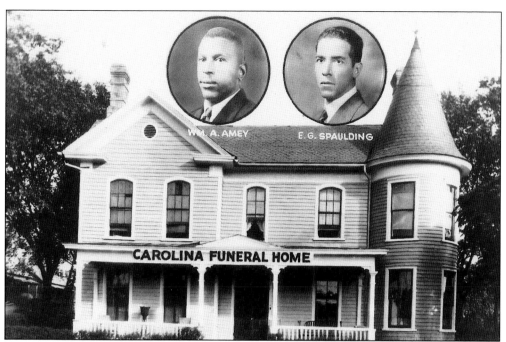

William Anderson Amey (1900–1981) and Emanuel G. Spaulding (1886–1969) directed the Carolina Funeral Home at 401 Pine Street in the 1930s and early 1940s. Amey was a grandson of Anderson Amey, a slave on the Bennehan-Cameron plantation, and Spaulding was a younger brother of Charles Clinton Spaulding. E.G. Spaulding subsequently moved to Brooklyn, New York, and after World War II the firm became known as Amey's Funeral Home. Amey's wife, Essie S. Amey, operated a florist business and assisted in the funeral parlor. William A. Amey Jr. later directed the enterprise, which by 1972 was located on Fayetteville Street.

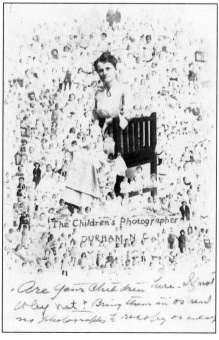

The woman identified on the postcard as "The Children's Photographer" and surrounded by a collage of young people is Katie L. Johnson (1874–1964). She was practicing the photography profession in Durham by 1900 and continued in the business into the 1930s. At the bottom of the advertising card, Johnson includes the following message directed to parents: "Are your children here[?] If not[,] why not? Bring them in or send us photographs to recopy or enlarge."

This is a photograph of the new building of the Durham Ice Cream Company, erected in the mid-1920s at the corner of West Main and Duke Streets. James H. Baer founded the business about 1916, and he operated the enterprise until his death in 1935. Afterward, his son, H.L. Baer, managed the company into the 1950s. It offered the "Blue Ribbon" brand of ice cream, a favorite among the public. At present, Torero's Mexican Restaurant and Lounge occupies the building.

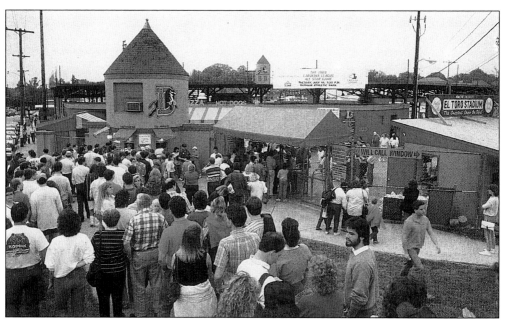

Fans of the Durham Bulls baseball team stand in line for tickets at the Durham Athletic Park in the 1980s. This modern postcard shows the distinctive box office tower at the "DAP," and the large crowd is evidence of the popularity of minor league baseball in Durham. The first ballpark on this site was El Toro Park, built in 1926. Following a fire in 1939, it was rebuilt and remained the home of the Bulls until the team moved to the new Durham Bulls Athletic Park in 1994.

Six

EDUCATIONAL
INSTITUTIONS

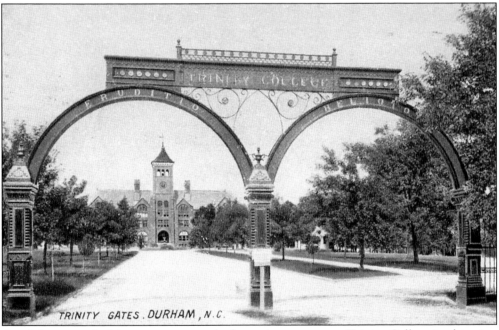

An elaborate arched iron gateway guards the main entrance to Trinity College in this view from about 1908. The college had relocated from Randolph County to Durham in 1892 when local tobacco manufacturers Washington Duke and Julian S. Carr donated money and land. When the school demolished the gate about 1914, the letter *T* of the word "Trinity" was preserved and hangs in an office of the Duke University Archives. Visible in the background is the Washington Duke Building, which was completed in 1892 and served as the college's original classroom and administrative facility.

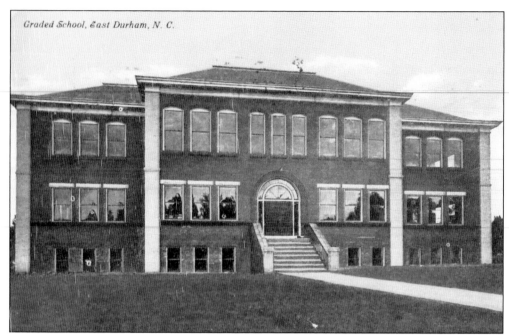

This postcard view of the East Durham Graded School was mailed in September 1912. The two-story-and-basement brick structure was completed in 1909 on Driver Avenue south of East Main Street. The school has been enlarged over the years and in the 1940s was renamed Y.E. Smith School in honor of Young E. Smith (1872–1939), a former legislator, school board member, and councilman. It closed in 1967 when a new Y.E. Smith School was erected on East Main Street.

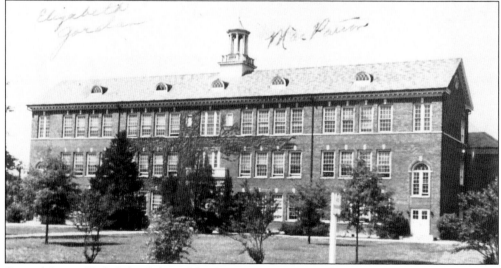

Central Junior High School, bound by Gregson, Morgan, and Duke Streets, opened its doors in 1926. Architect George Watts Carr Sr. (1893–1975) designed the Colonial Revival-style building. The school became Julian S. Carr Junior High in 1945 in honor of the one-hundredth birthday of one of the foremost citizens of Durham. The junior high closed in 1975, but for a time Durham High School occupied the structure. The Durham Magnet Center for Visual and Performing Arts presently utilizes the building. (Courtesy of Betsy M. Holloway.)

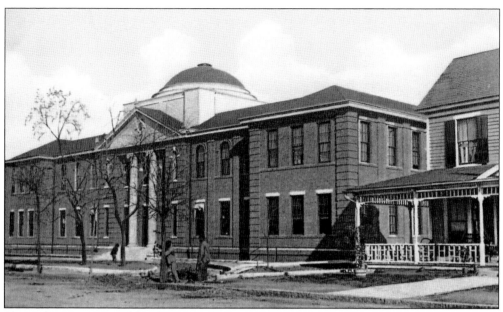

Shown here is a ground-level view of the City High School on Morris Street about the time of its opening in September 1906. The Neoclassical-style, two-story, red brick structure served white high school students of the city until 1922. Afterward the building became Durham City Hall and served in that capacity until the 1970s. The facility presently houses the Durham Arts Council and in 1988 was renamed the Royall Center for the Arts in honor of former legislator Kenneth C. Royall Jr. (b. 1918).

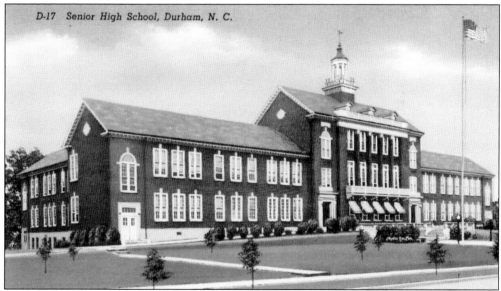

At the time this linen postcard was printed, Durham High School had been operating for nearly twenty years. The school opened in 1922 on North Duke Street on property that once belonged to Brodie L. Duke. The architectural firm of Milburn and Heister designed the building in the Neoclassical Revival style. For many years the high school excelled in academics and athletics before closing in 1993. The building is now part of the Durham Magnet Center for Visual and Performing Arts.

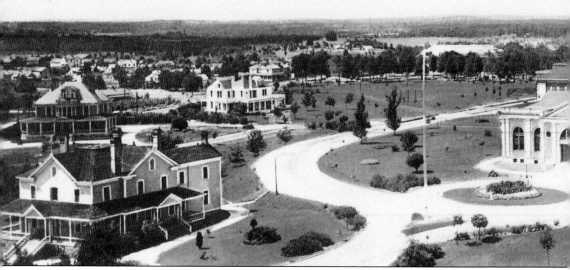

About 1906, a photographer climbed the bell tower of the original Washington Duke Building to take this elevated view of the campus of Trinity College, looking north. The postcard publisher employed a two-card foldout to represent the panoramic photograph. The large buildings shown left to right are the Mary Duke Building (left foreground), Craven Memorial

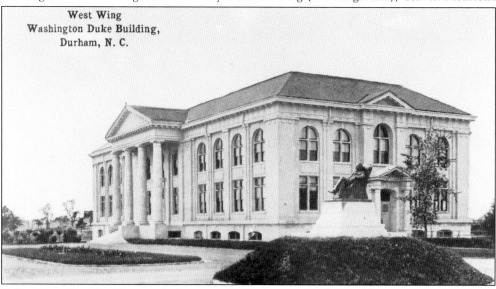

West Wing
Washington Duke Building,
Durham, N. C.

Following a fire that destroyed the original Washington Duke Building in early 1911, two identical Duke buildings supplanted the old structure. Depicted here is the West Duke Building (completed in 1910), which, along with its counterpart, the East Duke Building (1912), formed the entrance to the campus. Between the structures is the Washington Duke Statue, unveiled in 1908. (Courtesy of Duke University Archives.)

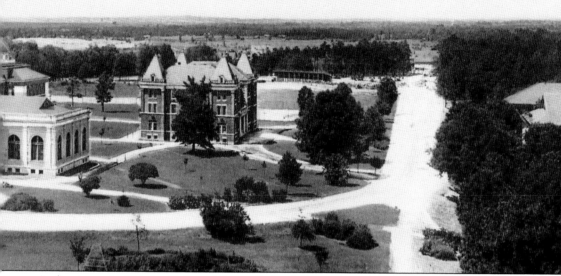

From, Frank.

Auditorium, the Trinity College Library (behind Craven), and Alspaugh Dormitory. The site was formerly known as Blackwell Park, a 62-acre pleasure resort where fairs and horse races were held. The old grandstand on the oval track is visible beyond the dormitory. (Courtesy of Betsy M. Holloway.)

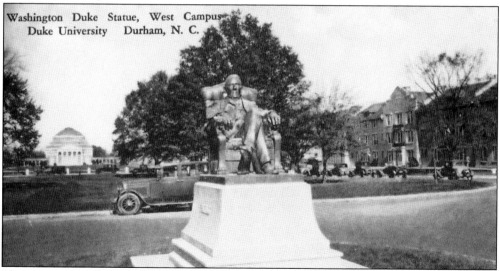

Washington Duke Statue, West Campus
Duke University Durham, N. C.

This postcard includes a close-up view of the Washington Duke Statue on the East Campus (Woman's College) of Duke University about 1930. The building in the distance is the Woman's College Auditorium, and at right is Aycock Dormitory. During the construction of the coordinate Woman's College of Duke University between 1925 and 1930, the statue had been moved a few hundred feet to the north and placed on flatter ground. The card's caption mistakenly locates the statue on the West Campus.

81

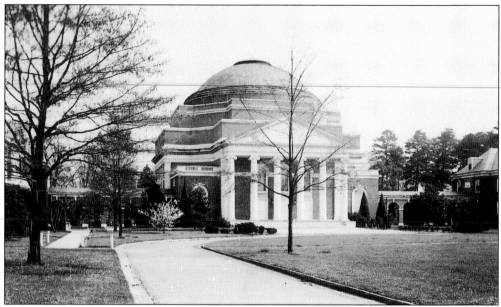

Photographer Carl W. Richardson, briefly a resident of Durham, took this photograph of the Woman's College Auditorium in the early 1930s. The facility, similar in design to the library planned by Thomas Jefferson at the University of Virginia, was renamed Baldwin Auditorium in the 1950s in honor of Mary Alice Baldwin (c. 1879–1960), the first female member of the Duke University faculty. (Courtesy of B.W.C. Roberts.)

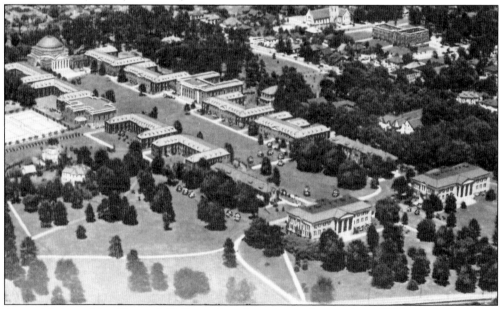

An aerial view of the Woman's College taken from the southwest about 1940 reveals the layout of the Georgian campus designed by the Philadelphia architectural firm of Horace Trumbauer. In the upper left corner is the auditorium, and at the lower right are the West Duke and East Duke Buildings. Visible in the upper right-hand portion of this card is a portion of what is presently known as the Trinity Park neighborhood, including Watts Street Baptist Church and George Watts Elementary School.

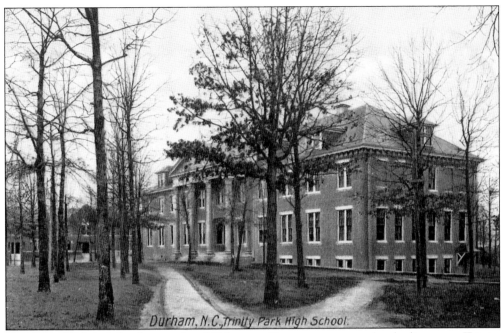

Trinity Park High School opened in 1898 as a college preparatory school adjacent to Trinity College. Pictured here is the Asbury Building, the administrative hall of Trinity Park School, as it was known by 1904. The school closed in 1922, and Trinity College acquired the buildings.

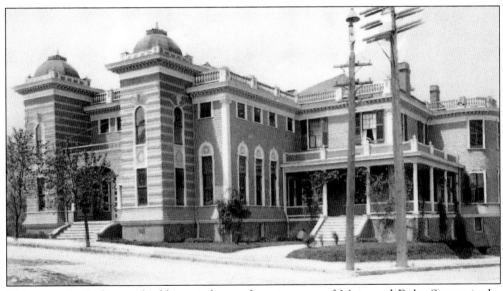

This tripartite Italianate building at the southwest corner of Main and Duke Streets is the Southern Conservatory of Music. The school opened in 1898, but this magnificent structure, financed by the Duke family, was not completed until 1900. The school offered quality musical instruction to young women of Durham and the South from that location until the early 1920s. The grand building was torn down in 1924 after the institution was moved to Alston Avenue. (Courtesy of Sarah M. Pope.)

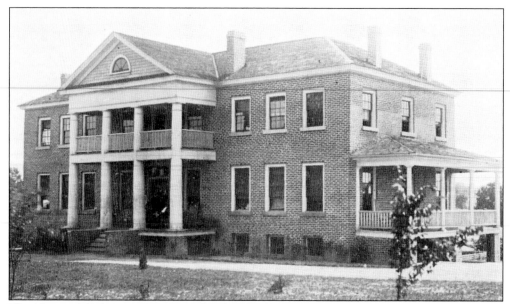

The National Religious Training School and Chatauqua, the forerunner of North Carolina Central University, opened in 1910 on land donated by Brodie L. Duke in the Hayti section of the city. The founder was Dr. James E. Shepard (1875–1947), who served as president until his death. This brick edifice served as the men's dormitory and was one of nine buildings on campus in the early 1910s.

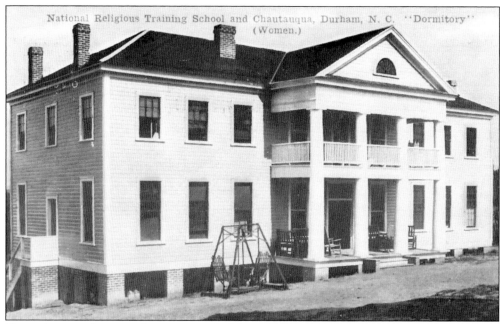

Shown here is a dormitory for women at the National Religious Training School and Chatauqua in the 1910s. The Bible school struggled to stay open during its first decade. Most of the early structures, such as this frame building, were destroyed by fire.

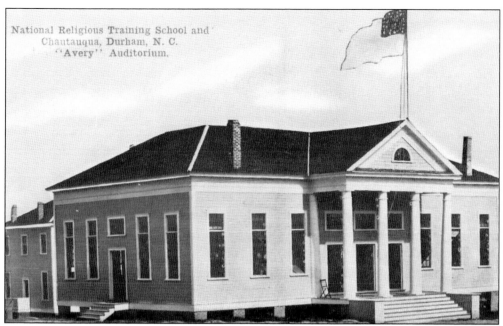

Avery Auditorium was one of the original buildings of the National Religious Training School and Chatauqua. It was named for John M. Avery (1876–1931), a local black leader and businessman. The wooden structure is no longer standing. (Courtesy of Betsy M. Holloway.)

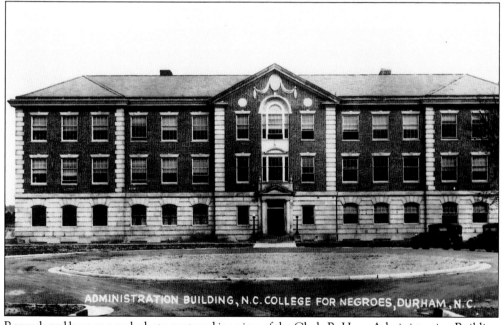

Reproduced here as a real-photo postcard is a view of the Clyde R. Hoey Administration Building at the North Carolina College for Negroes shortly after it was constructed in 1929. The school began receiving state support in the 1920s and became the Durham State Normal School. By 1929 the name had been changed to the North Carolina College for Negroes. (Courtesy of Special Collections Library, Duke University.)

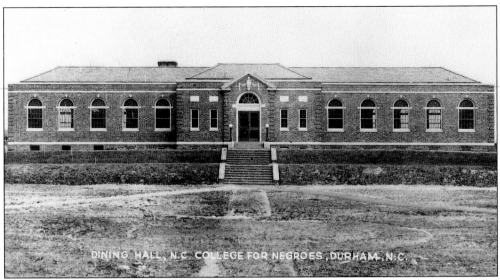

This real-photo card shows the dining hall at North Carolina College for Negroes in the early 1930s. The dining facility, known as the Alexander Dunn Building, was completed in 1930 in the Georgian Revival style. Appropriations from the state and donations from Benjamin N. Duke allowed the school to make steady progress in the 1920s and 1930s. In more recent times, the building was used as a center for academic skills. (Courtesy of Betsy M. Holloway.)

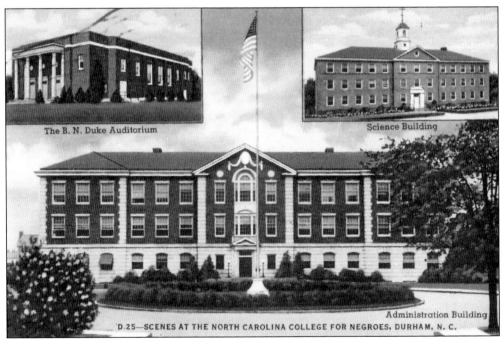

Pictured here is a collage of three buildings on the grounds of North Carolina College for Negroes in the 1940s. The structures include the B.N. Duke Auditorium, the William H. Robinson Science Building, and the Clyde R. Hoey Administration Building. Under the leadership of James E. Shepard, the institution became one of the nation's leading state-supported liberal arts colleges for blacks. In 1947 the school was renamed North Carolina College at Durham.

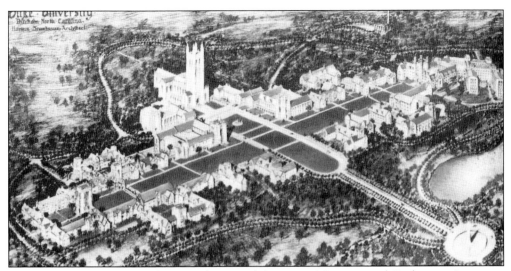

Reproduced on this postcard is an architectural drawing of the proposed Gothic men's campus at Duke University by the firm of Horace Trumbauer. The overly ambitious plan was later scaled back, and construction commenced in 1927. (Courtesy of Sarah M. Pope.)

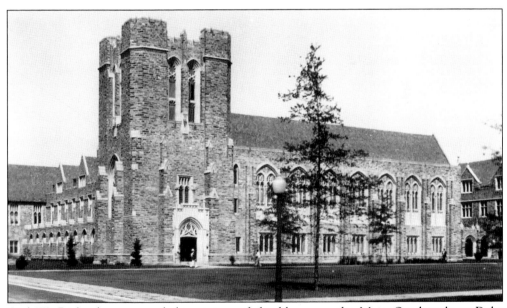

Carl W. Richardson snapped this picture of the library on the Main Quadrangle at Duke University shortly after it opened in 1930. The library was architecturally pleasing but had interior design flaws. It also quickly encountered space problems as a result of the rapid growth of its collections. The library was later named in honor of William R. Perkins (1875–1945), a close associate of James B. Duke.

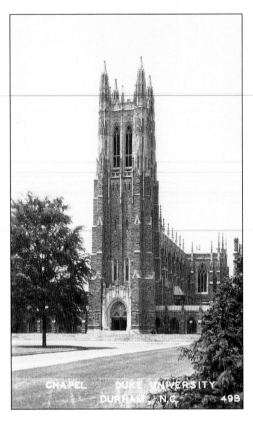

This c. 1940 exterior photograph of Duke Chapel displays the building's Gothic architecture embodied in the 210-foot tower. The centerpiece of the campus was begun in 1930 and first used in 1932. The university waited until after the installation of the stained-glass windows in 1935 to dedicate the building. The chapel is constructed of native volcanic stone selected because of its fourteen shades of color. (Courtesy of Sarah M. Pope.)

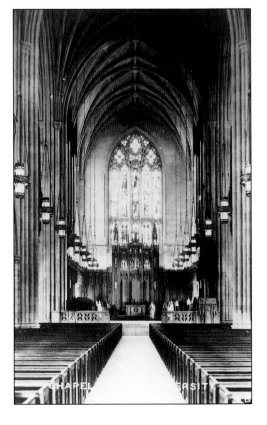

A photographer positioned himself in the center isle of the eighteen hundred-seat sanctuary to record this interior view about 1940. The photograph reveals the lofty arched support system, the magnificent stained-glass window at the west end, and the elaborately carved woodwork of the chancel. (Courtesy of Duke University Archives.)

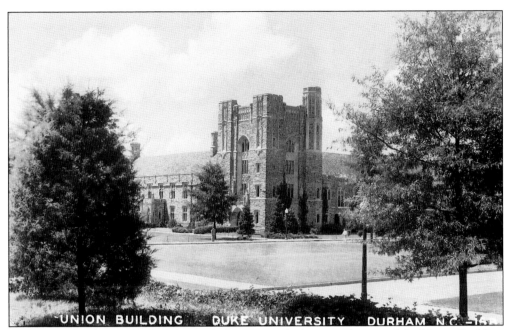

Carl W. Richardson published this real-photo view, looking southwest, of the Union Building in the early 1940s. The Union Tower, at the center of the photograph, is richly decorated with stone figures and college and university shields. No two towers on the campus are alike.

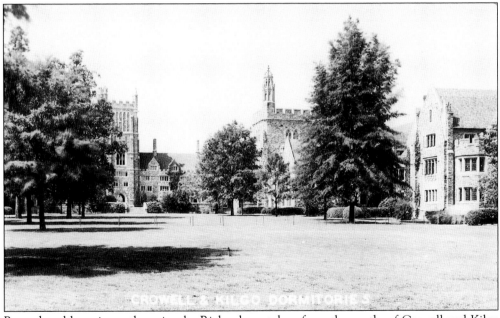

Reproduced here is another view by Richardson, taken from the south, of Crowell and Kilgo Dormitories at Duke University about 1940. On the left is the Crowell Tower, named in honor of John F. Crowell (1857–1931), former president of Trinity College. In the center is the Kilgo Tower, named after John C. Kilgo (1861–1922), another early president of the college. At the right is Kilgo House, one of the dormitory groups. (Courtesy of B.W.C. Roberts.)

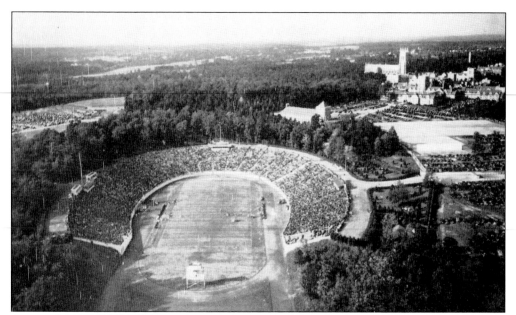

An aerial view of Duke Stadium shows a near-capacity crowd at a football game during the era of the "Iron Dukes" in the late 1930s. The horseshoe-shaped stadium was completed in 1929 and was the site of the famous transplanted Rose Bowl game between Duke and Oregon State on New Year's Day in 1942. At the right tip of the horseshoe one can observe the partially filled racially segregated section of the arena.

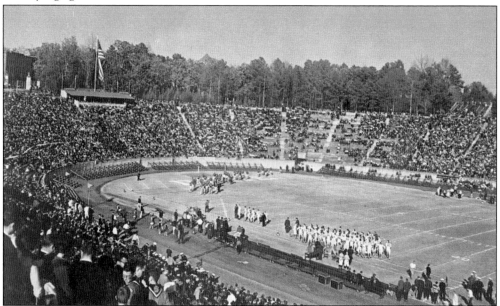

The Duke Blue Devils met the second-ranked Midshipmen of the U.S. Naval Academy on November 16, 1963, at Duke Stadium. This picture was taken from the west stands during the pregame introduction of the players to a regional television audience. The compiler was one of the forty-one thousand people who attended the high-scoring football game won by Navy, 38–25. The stadium was renamed in 1967 in honor of Wallace Wade (1892–1986), the legendary coach and athletic director.

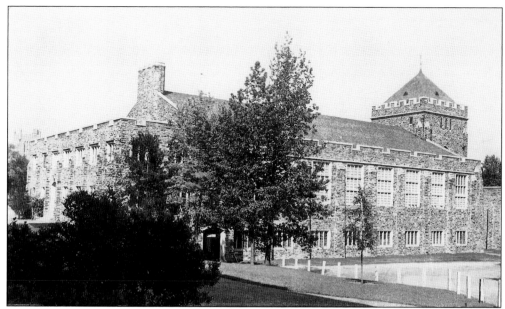

Card Gymnasium opened with the rest of the Duke University campus in September 1930. Reproduced here is a late-1930s photograph of the facility, named for W.W. "Cap" Card (1874–1948), a former Trinity College athlete and coach. Basketball became so popular that within ten years the Indoor Stadium (later known as Duke Indoor Stadium) replaced Card Gym as the home of intercollegiate games.

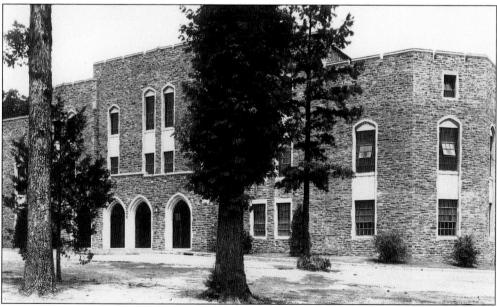

The Indoor Stadium was dedicated on January 6, 1940, when Duke beat Princeton, 36-27, before a crowd of eight thousand people. Money from the 1939 Rose Bowl helped finance the new $400,000 building, and profits from the 1945 Sugar Bowl finished paying for it. At the time of its opening, the building was the largest arena south of the Palestra in Philadelphia. In 1972 the gymnasium was renamed Cameron Indoor Stadium in honor of former coach and athletic director Edmund M. Cameron (1902–1988). (Courtesy of B.W.C. Roberts.)

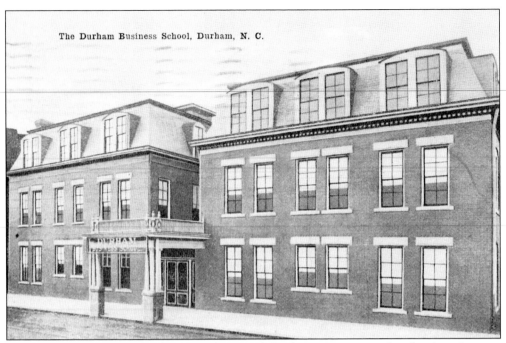

The Durham Business School was surely one of the first institutions of its kind in the city. Mrs. Walter Lee Lednum founded the school in 1914 and five years later moved it into the double-winged building pictured here. The structure was erected as the Corcoran Hotel on East Chapel Hill Street about 1907 and served as Mercy Hospital for a few years before becoming the business school.

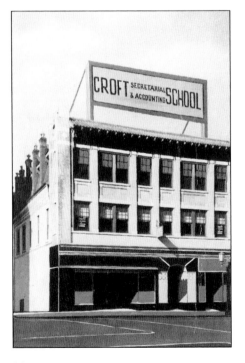

Mr. and Mrs. Claude A. Croft founded Croft Secretarial and Accounting School in 1931. Five years later the school moved into the second floor of the building shown here (formerly the Wright Corner) at the southwest intersection of Main and Corcoran Streets. The school offered day and night courses to male and female high school or college graduates. Croft Business College, as it was later known, relocated to Market Street and was closed by the early 1970s. A branch of Wachovia Bank and Trust Company now occupies the Main Street site.

Seven

Dealing with Disaster

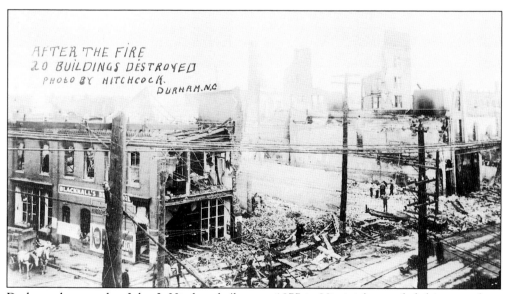

Durham photographer John J. Hitchcock (born c. 1877 in Virginia) recorded this scene from the top of a building on the Wright Corner in the aftermath of the disastrous fire that destroyed twenty buildings on Main Street near the corner of Corcoran Street on March 23 and 24, 1914. Bystanders are examining the rubble and assessing the damage near Blacknall's Drugstore.

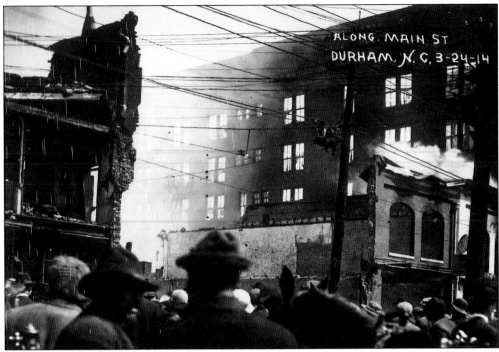

Onlookers survey the destruction caused by the fire in this close-up view during the early morning hours of March 24. The remains of several buildings are still smoldering from the blaze. (Courtesy of Special Collections Library, Duke University.)

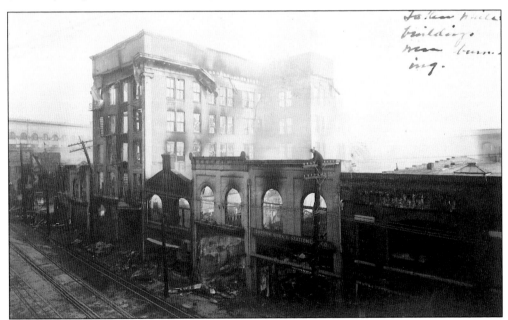

The fire began in the five-story Brodie L. Duke Building pictured here at the center of the 100 block of West Main Street. Weak water pressure hampered firemen and, along with strong winds, allowed the fire to engulf surrounding structures. A man atop an electric power pole risks his life in an attempt to disconnect the electricity.

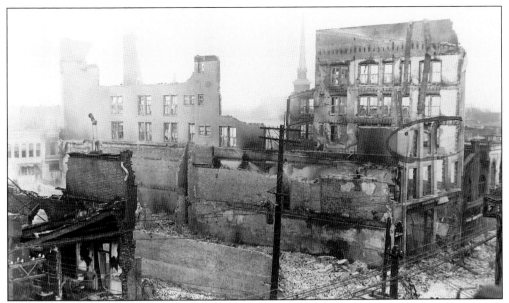

Firemen gained control of the fire by 2:00 am on March 24, but the blaze continued for several more hours. The end result was these burned-out shells of buildings on the north side of Main Street. On the left is Blacknall's Drugstore, and on the right, the remains of the Brodie L. Duke Building are visible. Behind the Duke Building is the undamaged steeple of the Trinity Methodist Church.

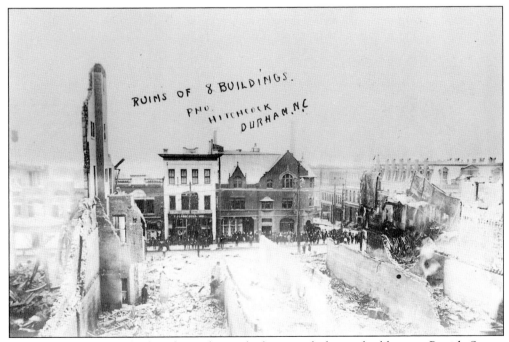

John J. Hitchcock made this elevated view looking south from a building on Parrish Street. The resulting devastation gave the cameraman a clear view from Parrish to Main Street. In the center of the picture is the First National Bank, which shortly thereafter was replaced by the eight-story building that occupies the site today. (Courtesy of Willard E. Jones.)

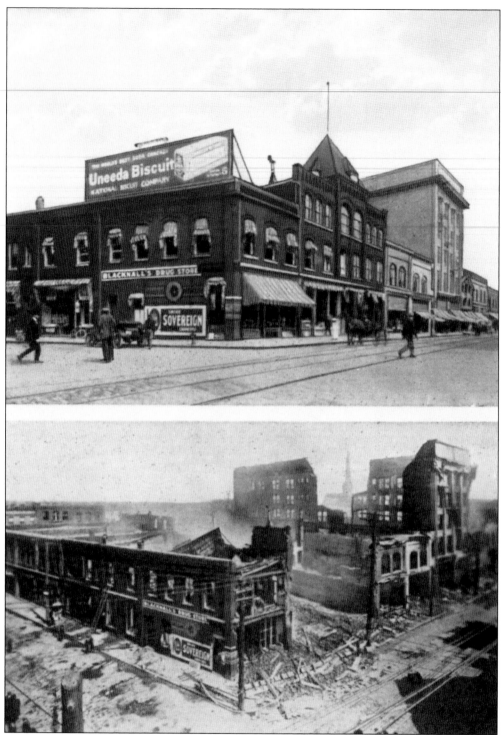

This commercially produced postcard includes twin views looking northeast of the section of the city as it appeared before and after the conflagration. The blaze caused more than one million dollars in damage and at that time was the most destructive disaster in the city's history.

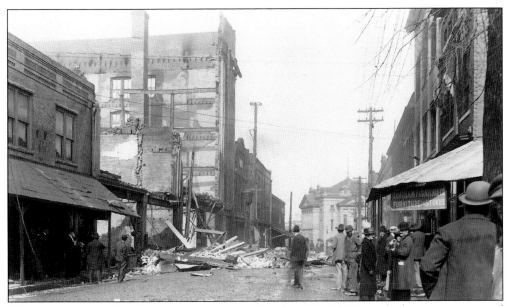

The photographer placed his camera on the north side of Parrish Street, looking west, to record curious onlookers examining the ruins on the north side of the fire. On the right side of the street are the undamaged buildings that housed the North Carolina Mutual and Provident Association and the Mechanics and Farmers Bank. At the west end of Parrish Street is the unharmed Academy of Music.

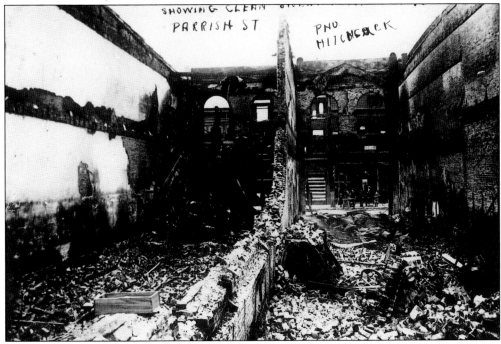

Hitchcock positioned himself close to the debris to get this picture of the destruction from Main Street looking north to Parrish Street. The city quickly rebuilt the burned-out area and made improvements in its fire-fighting capability in hopes of preventing a future disaster. (Courtesy of Special Collections Library, Duke University.)

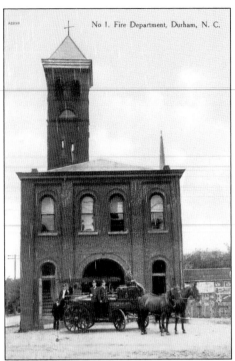

No 1. Fire Department, Durham, N. C.

Firemen pose with their horse-drawn fire engine in front of the No. 1 Fire Department at the corner of Mangum and Holloway Streets about 1910. The firehouse was constructed in 1890 for $3,000 and was described as one of the best-equipped stations in the state. The two-story red brick building had an electrical alarm system and an 829-pound bell in its tower. The fire department later replaced the station with the building that stands today. The Durham Department of Housing presently occupies the structure.

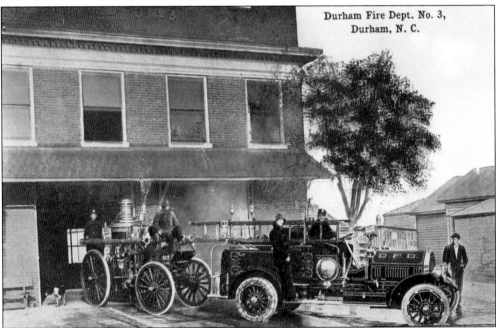

Durham Fire Dept. No. 3, Durham, N. C.

Durham Fire Department No. 3 was completed in 1911 at 601 (later 527) East Main Street. Here firefighters exhibit an old-fashioned horse-drawn fire wagon alongside a new motorized engine (known as the "Red Devil"). Gasoline-powered vehicles replaced horse wagons about 1915. Durham firemen, not entirely comfortable with the new technology, for a time utilized the motorized vehicles to tow the more familiar horse-drawn equipment to fire scenes. In 1955 the City moved the station to 101 South Driver Avenue.

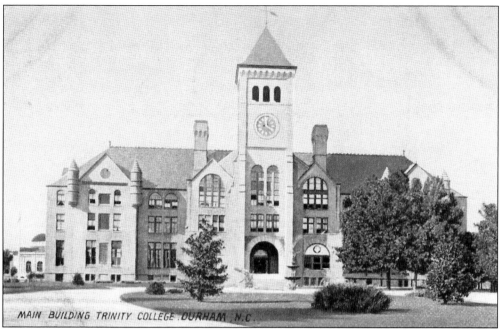

The Washington Duke Building, an impressive Norman Revival-style edifice completed in 1892, was the original classroom and administrative building on the new Durham campus of Trinity College. The three-and-one-half-story brick structure included a five-story clock tower. During construction, the almost completed tower collapsed and was rebuilt with stronger support at its base.

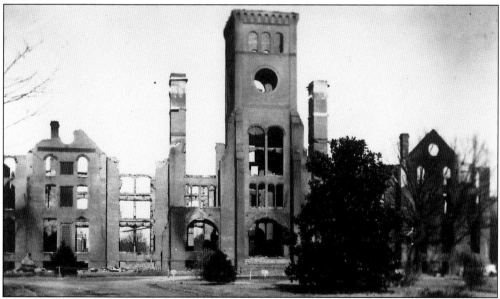

Reproduced here from a real-photo postcard is a view of the ruins of the original Washington Duke Building following a fire in the early morning hours of January 3, 1911. At the time of the blaze, plans were under way to replace the nineteen-year-old edifice. The sturdily constructed building was difficult to demolish. The identical West Duke (1910) and East Duke (1912) Buildings replaced the destroyed administrative hall. (Courtesy of Duke University Archives.)

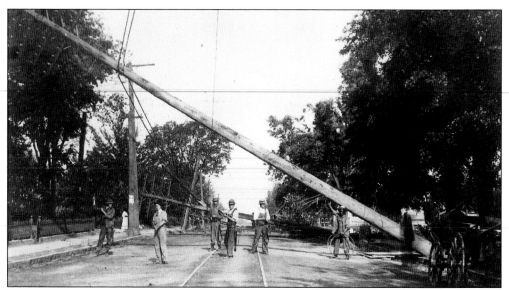

Workmen pause briefly for the camera on East Chapel Hill Street while removing fallen electrical power poles knocked over by strong winds in the early 1910s. The high wind, perhaps the result of a summer thunderstorm, brought down several poles in this residential section. (Courtesy Special Collections Library, Duke University.)

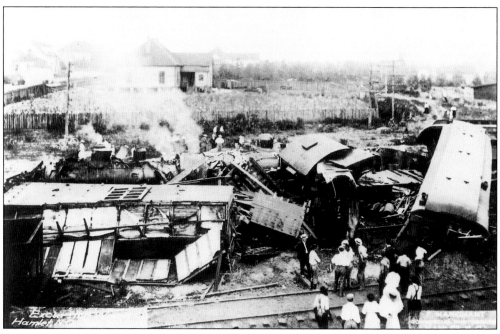

A summer religious outing in 1911 sponsored by St. Joseph African Methodist Episcopal Church of Durham ended in tragedy with a rail accident in Hamlet, North Carolina. The passenger train from Durham, bound for Charlotte with more than nine hundred people aboard, collided head-on with a slow-moving freight train near the Seaboard Air Line roundhouse near Hamlet. This view from July 27, 1911, shows the wreckage of the train, which resulted in nine deaths and eighty-eight injuries. (Courtesy of North Carolina Division of Archives and History.)

Eight

HOUSES OF WORSHIP

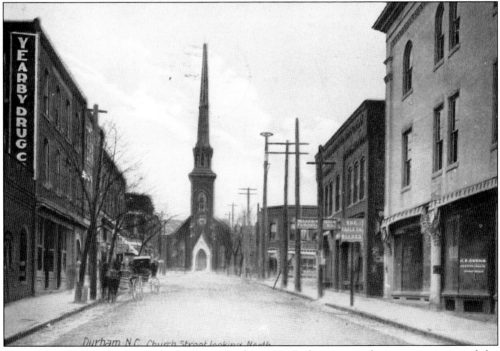

This view of Church Street, looking north about 1907, focuses on the towering spire of the Trinity Methodist Church at the head of the street. Downtown churches played an important role in the development of the city of Durham in the early twentieth century.

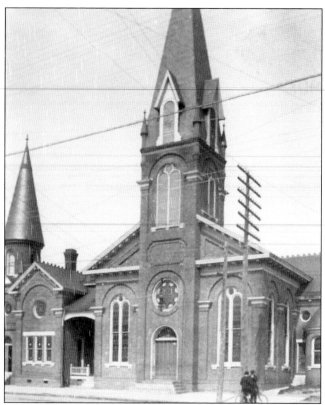

The First Baptist Church was the oldest congregation to establish itself in the Durham community, having opened a church in 1850. The brick structure pictured here about 1905 was opened in 1878 on Mangum Street and was the third building to house the congregation in Durham. In 1905 the rapidly growing church had seven hundred and fifty members. The structure was demolished after the members moved into the present sanctuary on Cleveland Street in 1927. (Courtesy of B.W.C. Roberts.)

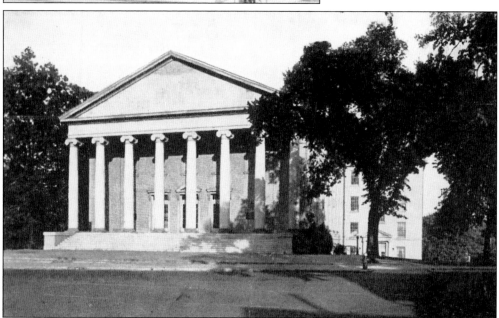

This 1930s postcard pictures the First Baptist church's fourth building in Durham at 414 Cleveland Street, at the east end of Chapel Hill Street. The Neoclassical Revival-style house of worship, containing an eleven-hundred-seat sanctuary, was erected in 1927 and still serves the congregation. (Courtesy of Durwood Barbour.)

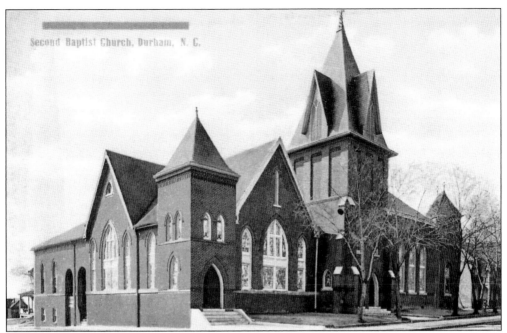

The Second Baptist Church of Durham had its origins as the Blackwell Baptist Church in 1888. The named was derived from Eleanor Blackwell, the mother of tobacconist William T. Blackwell (1839–1903), who donated property on West Chapel Hill Street for the church. In 1890 the name was changed to the Second Baptist Church. This postcard, from about 1911, includes a view of the additions made to the church at the corner of West Chapel Hill and Shepherd Streets. The church was renamed Temple Baptist Church in the late 1910s. The current sanctuary stands at the same location.

Churches often used postcards to promote their religious programs, such as Sunday school classes. Members of the all-male Baraca Bible Class of the Second Baptist church pose for the photographer about 1908. The congregation had four hundred and fifty active members at that time. (Courtesy of North Carolina Division of Archives and History.)

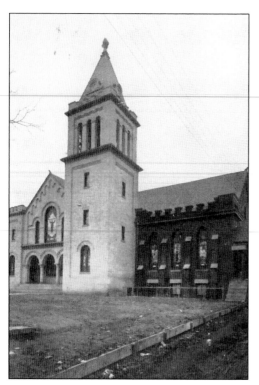

This 1911 photograph of White Rock Baptist Church was taken shortly after alterations and improvements were made to the 1896 structure at the corner of Mobile Avenue and Fayetteville Street. The church was the spiritual home of many executives of North Carolina Mutual Life Insurance Company and the center of African-American life in Durham. The congregation moved to its present location at 3400 Fayetteville Street in 1971. (Courtesy of Betsy M. Holloway.)

The West Durham Baptist Church was organized in 1894 as a mission of the First Baptist Church. The church erected the frame structure pictured here about 1898 on Blacknall Street in West Durham. The compiler's mother grew up in the community near Erwin Mills and was baptized at this church about 1928. A new house of worship on Hillsboro Road replaced the wooden church in 1936 and received the name Grey Stone Baptist Church in 1949.

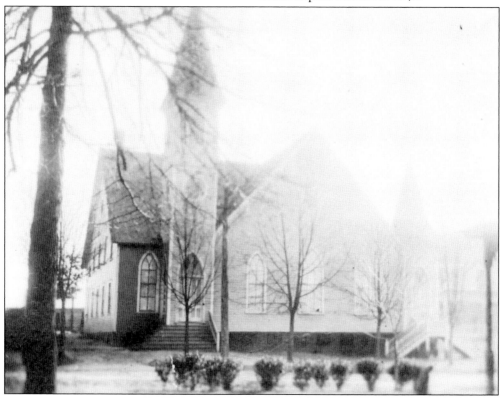

The postcard publisher was obliged to use a vertical-format picture in order to include all of the 120-foot steeple of the Trinity Methodist Church in this 1905 view. Methodists had built their first church on the site in 1880 and had enlarged the building in the early 1890s to accommodate its growing membership. A spectacular fire destroyed the Durham landmark at Church and Liberty Streets in January 1923.

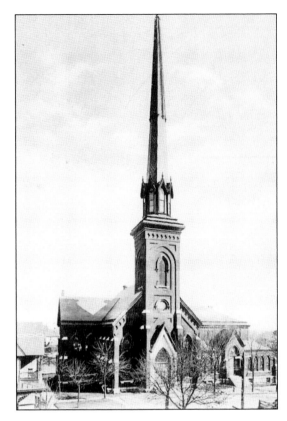

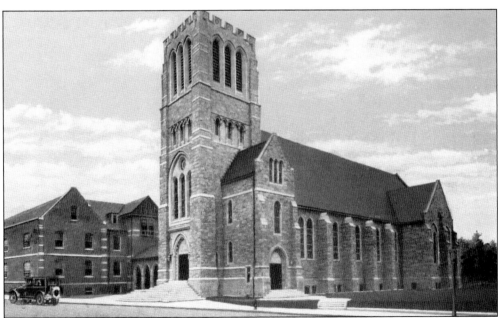

This Gothic Revival-style church opened in 1924 on the site of the burned building lost in the fire of the previous year. Ralph Adams Cram, a noted ecclesiastical architect of Boston, designed the church. This view, from the 1930s, includes the Sunday school or education wing at left.

Members of the Julian S. Carr Bible Class of Trinity Methodist church pose on the front steps of the building in this photograph from the late 1940s. One of the prominent citizens who were members of the Trinity Methodist congregation was North Carolina governor Willam B. Umstead, whose state funeral was conducted at the church on November 9, 1954.

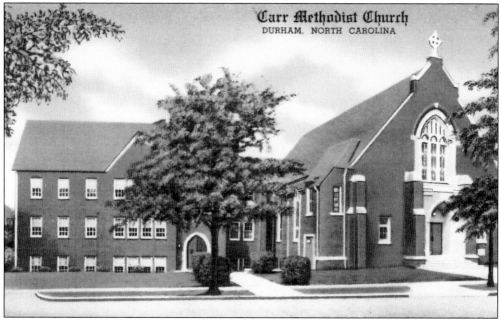

Carr Methodist Church
DURHAM, NORTH CAROLINA

This 1950s linen-style postcard depicts Carr Methodist Church at 107 North Driver Avenue in East Durham. The congregation had its beginnings in 1886 as a Sunday school at the Durham Cotton Manufacturing Company. Later that year, Julian S. Carr made possible the erection of a frame church across the railroad tracks from the mill. Members began worshiping at the Driver Avenue location in the 1930s, but the sanctuary was not completed until 1948.

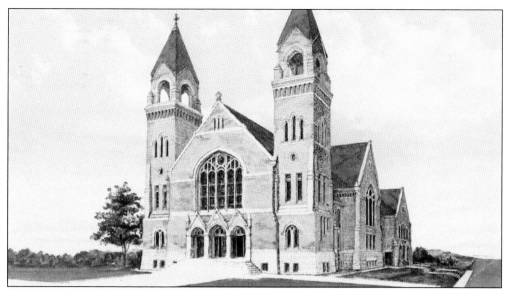

This card, postmarked in 1912, bears an image of the Memorial Methodist Church on the former site of the William T. Blackwell home at the corner of West Chapel Hill and Duke Streets. The church began in 1885 as a Sunday school class in the Duke tobacco factory. The following year a church building was completed at the corner of Main and Gregson Streets, and the congregation adopted the name Main Street Methodist Episcopal Church. Work commenced on the current structure in 1907, and the first service took place in the sanctuary in 1912. The house of worship was named Memorial Methodist Church in 1908 and in 1925 was renamed Duke Memorial Methodist Church in honor of Washington Duke.

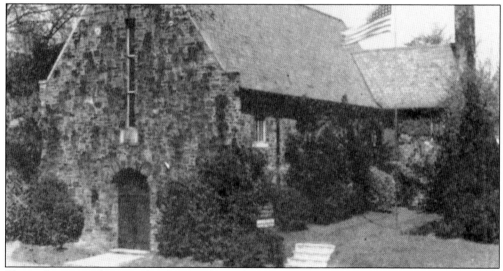

Shown here is a photograph of St. Paul's Lutheran Church taken during World War II, when it operated the Lutheran Service Center for members of the armed forces at its location at the corner of Yates Avenue and Chapel Hill Street. The church had been organized in 1923 and occupied this sanctuary in 1929. The postcard, mailed from Pvt. R.J. Blaknic to his parents in Wisconsin, contained the following message: "Believe it or not—I'm spending a full 3[-]day pass in a Lutheran Service Center home, doing nothing but sitting down & resting. That's <u>living</u>." (Courtesy Willard E. Jones.)

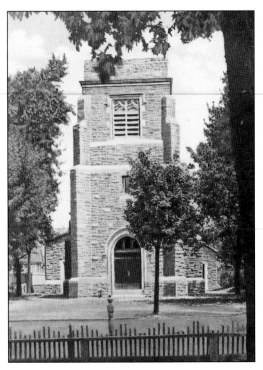

A photographer stood directly in front of the entrance to St. Philips Church on East Main Street to record this view in 1908. The house of worship, based on the Gothic Revival design of well-known architect Ralph Adams Cram, was constructed in 1907. The new stone church, which is still in use today, replaced a wooden structure that the Episcopalians had used since the congregation was founded in 1880.

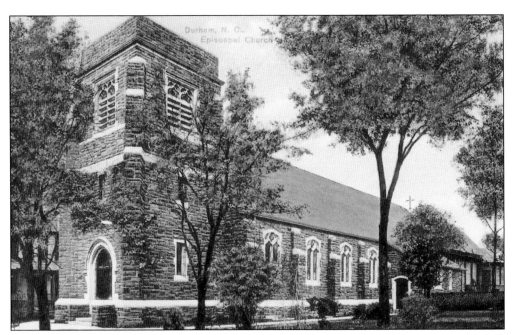

Durham Book and Stationery Company published this postcard of St. Philips Episcopal Church about 1910. The church is 123 feet long by 55 feet wide and seats some four hundred and fifty people. Founders of the house of worship named it for St. Philip the Deacon in honor of the diaconate of Joseph Blount Cheshire Jr. (1850–1932), a Chapel Hill minister and later Episcopal bishop of North Carolina, who conducted services during the early years of the congregation.

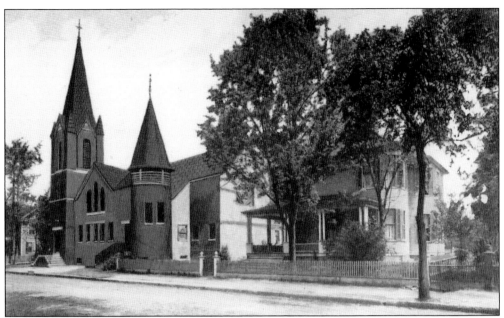

The Presbyterians were the third denomination to construct a church in Durham. They formed a congregation in 1871 and four years later erected a frame sanctuary on East Main Street at Roxboro Street. Following a steady growth in membership, the substantial brick church shown here supplanted the wooden building in 1890. Visible at the right of the First Presbyterian Church is a two-story manse. (Courtesy of B.T. Fowler.)

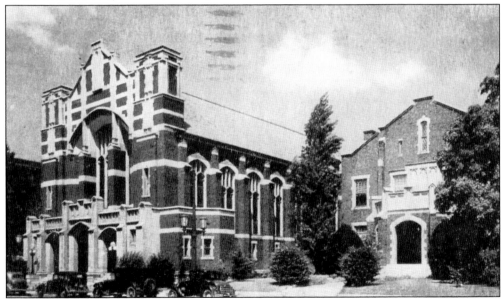

In 1916 a third church edifice was completed to replace the 1890 building. The architectural firm of Milburn and Heister designed the red-brick-and-limestone Gothic-style house of worship. Durham philanthropist and ruling elder of the church, George W. Watts, donated most of the funds needed to construct the house of worship. Watts also was responsible for the completion of the chapel on the right side of the sanctuary. The First Presbyterian congregation continues to worship in these buildings.

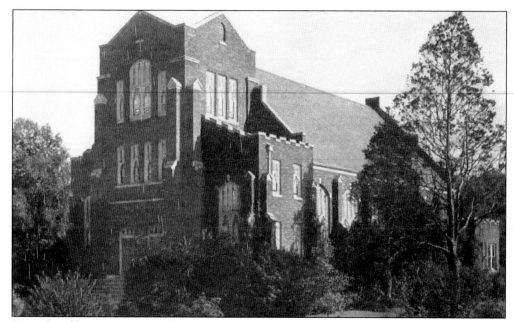

Reproduced here is an image of Trinity Avenue Presbyterian Church as it appeared in the 1930s. The origin of the church can be traced to the establishment of a Sunday school mission for workers at the Pearl Cotton Mill in 1895. Early in the twentieth century the church reorganized as the Second Presbyterian church. It adopted its present name in 1921 and four years later moved into the Neo-Gothic Revival-style building on West Trinity Avenue. In 1951 the compiler received the rites of infant baptism at the church. The sanctuary is still in use.

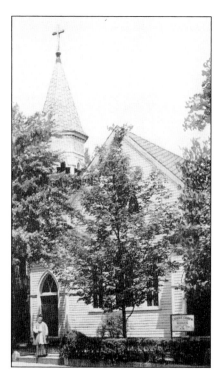

Monsignor William Francis O'Brien (1872–1960) stands at the entrance to the Church of the Immaculate Conception on West Chapel Hill Street in the late 1930s. Father O'Brien moved to Durham in 1907 and was the first resident Catholic priest in the city. He also established a parochial school now known as Immaculata Catholic School. Father O'Brien retired in 1951 before the current church replaced this old wood-frame building in 1957.

Nine

AROUND THE COUNTY

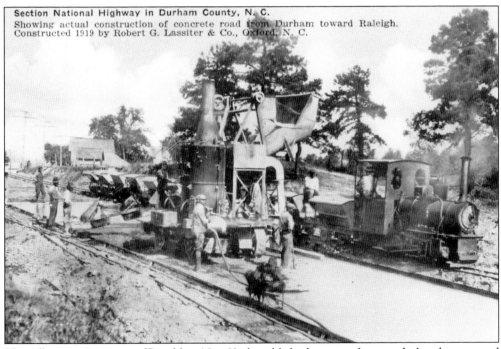

The Albertype Company of Brooklyn, New York, published a series of postcards that documented road construction in Durham County. In this view, employees of Robert G. Lassiter and Company of Oxford, North Carolina, are shown constructing a concrete road from Durham toward Raleigh in 1919. (Courtesy of Sarah M. Pope.)

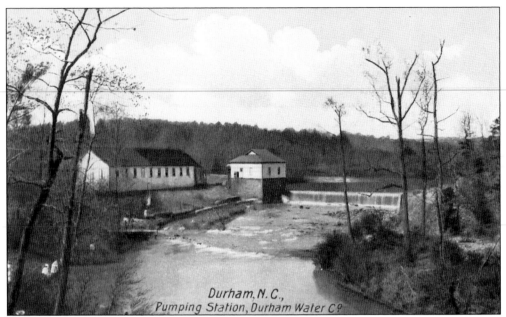

A private corporation known as the Durham Water Company operated a pumping station 8 miles north of the city on the Eno River, producing Durham's water supply during the late nineteenth and early twentieth centuries. Dissatisfied with that water source, the growing city decided to draw its water from the Flat River. As a result of that decision, the dam that created Lake Michie was completed in 1926.

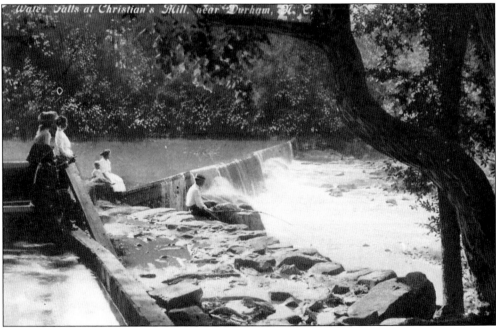

The setting for this rustic photograph (c. 1910) was Christian's Mill on the Eno River, a few miles north of the city. At that time William J. Christian (1859–1920), a former mayor, owned the gristmill. The mill has been restored and is presently known by its older name—West Point on the Eno.

112

The photograph reproduced on this postcard was taken about forty years after Confederate general Joseph E. Johnston surrendered his troops to Union general William T. Sherman at the farmhouse of James Bennitt (before 1810–1878) in April 1865. The home, situated about 3 miles northwest of Durham, was destroyed by fire in 1921. The house was reconstructed in 1961 and currently is a state historic site.

The Albertype Company published this picturesque view of Duke Homestead on a postcard about 1940. Built by Washington Duke in 1852, the home was the birthplace of his sons, Benjamin N. and James B., and his daughter, Mary Elizabeth. The family launched its tobacco-manufacturing business at this site after the Civil War. The Dukes moved into Durham in 1874, and Duke University preserved the homeplace. Named a National Historic Landmark in 1966, the farmstead became a state historic site in 1973.

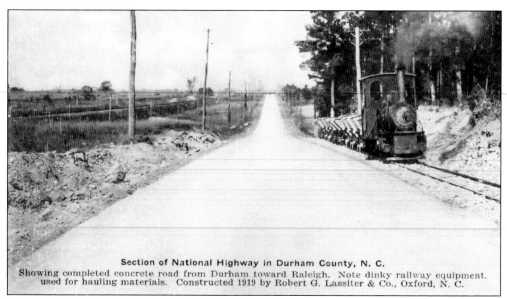

Section of National Highway in Durham County, N. C.
Showing completed concrete road from Durham toward Raleigh. Note dinky railway equipment.
used for hauling materials. Constructed 1919 by Robert G. Lassiter & Co., Oxford, N. C.

Julian S. Carr and Bennehan Cameron (1854–1925) used their political clout as state legislators to promote the good roads movement in Durham County. About 1916, Durham and Wake Counties received federal funds to construct a highway between Durham and Raleigh. Shown here is a completed section of the highway east of Durham in 1919. Robert G. Lassiter and Company employed a miniature steam engine train for hauling road-building materials. (Courtesy of Sarah M. Pope.)

Section of National Highway in Durham County, N. C.
Showing actual construction of concrete road from Durham toward Raleigh
Constructed 1919 by Robert G. Lassiter & Co., Oxford, N. C.

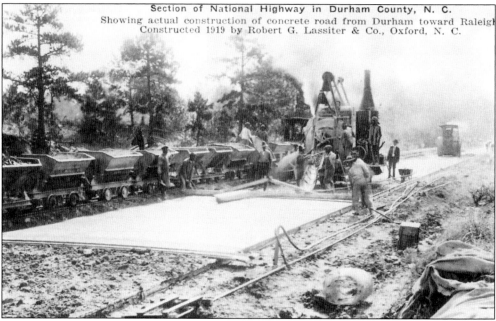

This close-up scene (1919) shows employees of Robert G. Lassiter and Company paving a section of the national highway that will connect Durham and Raleigh. Workers empty gravel from the train cars into a roadbed, and concrete is being poured from a steam-powered cement mixer. John Sprunt Hill, a state highway commissioner between 1920 and 1931, made sure that Durham County received some of the best roads in the state. (Courtesy of Sarah M. Pope.)

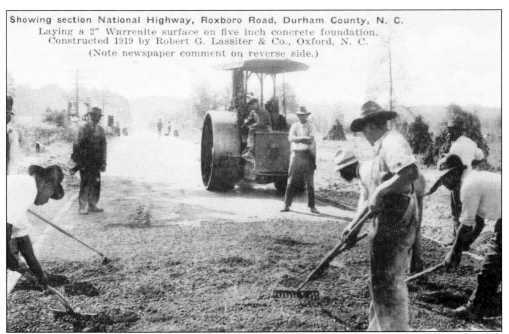

Robert G. Lassiter and Company was also working on a federally funded highway from Durham via Braggtown to Roxboro. Workmen are shown applying a surface of gravel to a 5-inch concrete foundation as a foreman and steamroller operator look on. By the fall of 1919, the contractor had completed the highway some 10 to 12 miles out from the city. (Courtesy of Sarah M. Pope.)

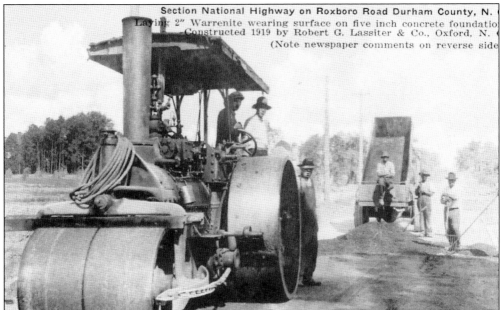

Shown here from the opposite direction, the steamroller pauses while a work crew spreads gravel on the concrete foundation of the Roxboro road. The Raleigh *News and Observer* of October 17, 1919, announced the completion of the highway and reported that a number of citizens had already "motored out" to see the new road. (Courtesy of Sarah M. Pope.)

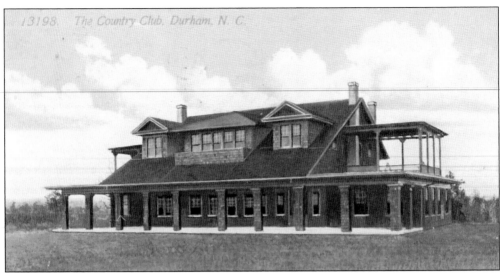

John Sprunt Hill, a golf enthusiast, was the force behind the incorporation of the Durham Country Club in 1912. Hill donated the use of the 9-hole golf course at his country estate, as well as 2 acres of land on which to build a clubhouse for the newly formed club. The organization constructed a two-story Dutch Colonial clubhouse in 1912 near the intersection of present-day Club Boulevard and Hillandale Road. Hill subsequently bought the club and in 1939 donated it to the Durham Foundation. The current clubhouse opened in 1961, and the old building was razed. Hillandale Golf Course hosted many Herald-Sun golf tournaments and is now a public facility.

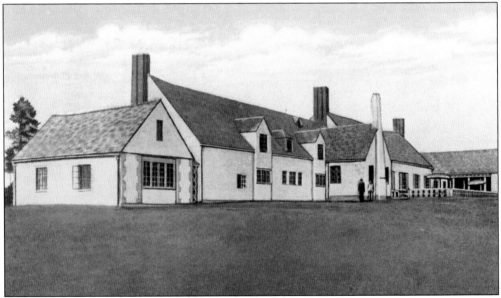

Durham's country club community of Hope Valley was taking shape in the late 1920s with the construction of the one-story Norman Provincial-style clubhouse and the development of the 18-hole golf course designed by famous golf architect Donald J. Ross. The suburban project, 4 miles from Durham, catered to affiliates of Duke University and the University of North Carolina. The links hosted numerous amateur and several professional tournaments, including the Durham "Jaycee Open," won by Byron Nelson in 1945.

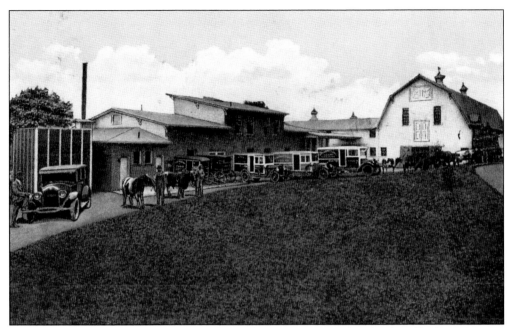

Lakewood Dairy probably was one of the earliest enterprises of its kind in Durham County. Frank A. Ward (1886–1928) and his family operated the business for several decades in the early twentieth century. This view of the dairy complex, located near James Street, is from the early 1930s. Pet Dairy Company purchased the operation in the late 1930s, and by 1947 Long Meadow Dairies had acquired the milk interests of Pet. (Courtesy of Betsy M. Holloway.)

The town of Durham opened Maplewood Cemetery in 1872 on land west of the community. It is the final resting place of many important citizens who played key roles in the growth of the city. This view shows the cemetery's main gate as it appeared about 1910. In recent times the cemetery opened an annex, and the old section is located on both sides of Kent Street near Morehead Avenue.

One of the most popular attractions at Duke University is the Sarah P. Duke Gardens. Begun in the early 1930s, they were dedicated on April 21, 1939, to memorialize Sarah P. Angier Duke, wife of Benjamin N. Duke. Distinguished American landscape architect Ellen Biddle Shipman designed the Terraces, the historical core of the gardens. Sarah P. Duke's daughter, Mary Duke Biddle (1887–1960), established a foundation in 1956 to endow the showplace. (Courtesy of Duke University Archives.)

The Carr Bldg., (Davee Hall on Left,) U. of N. C., Durham.—25

S.H. Kress and Company published a widely distributed set of postcards in the 1910s that erroneously located the University of North Carolina in Durham. Pictured here is one of the cards, showing the Julian S. Carr Building, which actually is located on the campus in Chapel Hill. Rapidly growing Durham, to the relief of the university, had not annexed Chapel Hill.

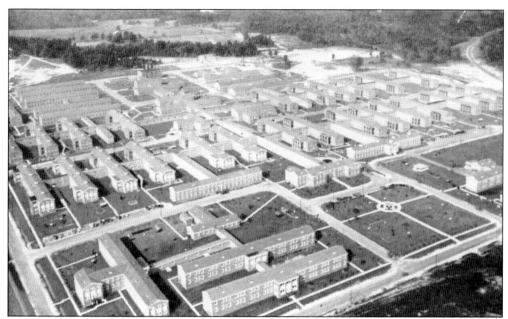

The United States Army Signal Corps provided these wartime postcards of Camp Butner. The military installation, which was situated in Durham, Granville, and Person Counties, opened in August 1942. The infantry training camp was named in honor of North Carolina general Henry W. Butner (1875–1937). Durham immediately cashed in on the prosperity generated by the military complex 10 miles to the north. The "Bull City" provided housing, supplies, food, transportation, and entertainment for the troops. After the war, the state acquired the base and established a mental hospital there in 1962. (Top image courtesy of Durwood Barbour.)

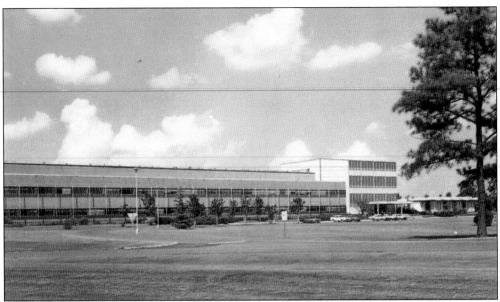

The North Carolina News Company published this postcard view of the Chemstrand Building in the 1960s. This research lab, which opened in 1961, was one of the early tenants at Research Triangle Park (1959). Chemstrand later became part of the Monsanto Company. This 6,800-acre park, located 6 miles southeast of Durham and lying mostly in Durham County, is one of the largest research and industrial development parks in the world.

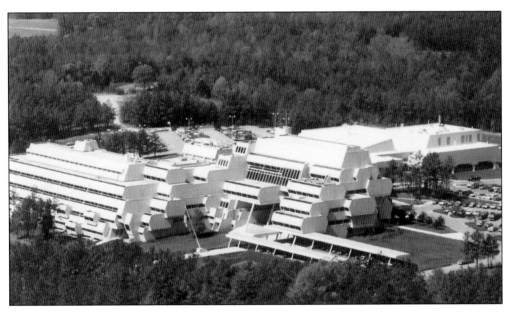

During the 1960s the federal government located various research agencies in Research Triangle Park. Computer giant IBM moved into the community in 1967, and pharmaceutical manufacturer Burroughs Wellcome followed in 1970. Pictured here is the corporate headquarters and research laboratories of Burroughs Wellcome, designed by Paul Rudolph. It is the most striking example of modern architecture in the park. The company recently merged with Glaxo Pharmaceuticals and is now known as Glaxo Wellcome, Inc. (Courtesy of B.W.C. Roberts.)

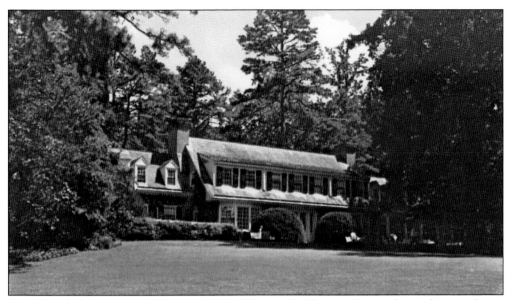

Reproduced above is a *c.* 1970 view of Quail Roost Conference Center, located in northwest Durham County near Rougemont. Quail Roost had its origins as a hunting club formed in the 1870s by the Duke family and other prominent tobacco men in Durham. John Sprunt Hill acquired the club in 1925 and presented it to his son George Watts Hill (1901–1993). The younger Hill erected a handsome Williamsburg manor, gave a large tract of land to North Carolina State University, and launched a large-scale dairy operation. Hill donated the house to the University of North Carolina in 1963, and it was used as a conference center until the university sold it following Hill's death.

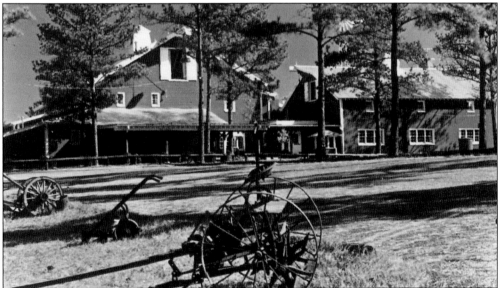

This postcard features a 1970s photograph of the Angus Barn, one of the area's most popular restaurants. Thad Eure Jr. opened the establishment in the mid-1960s on U.S. Highway 70 near the entrance to the Raleigh-Durham Airport between Durham and Raleigh. The restaurant's rustic design and self-proclaimed reputation as a "Beef-eaters' Haven" have made it an award-winning dining experience for more than thirty years.

Main Street was a bustling place during the 1940s, and hats were still in vogue for men. This crowd is strolling east on the north side of Main Street near VanStraaten's men's clothing store, the Durham Industrial Bank, and Roscoe Griffin Shoe Company.

Here's to Durham!

Here's to Durham, "The Friendly City",
 The gem of the "Old North State";
A home of peace, progress and plenty
 Where men may grow good and great.

Home of manufactured tobacco,
 Where mills and factories hum;
In busy, bustling, hustling Durham---
 A welcome awaits you! "Come!"

Copyrighted 1928, by MARY R. HOLEMAN.

Mary R. Holeman (1865–1938) was a native of Person County and later made her home in Durham. She was a gifted music teacher, member of the United Daughters of the Confederacy, and avid promoter of Durham. Holeman published this ode in honor of her adopted city in 1928. A border of tobacco leaves frames the promotional poem. (Courtesy of Leigh H. Gunn.)

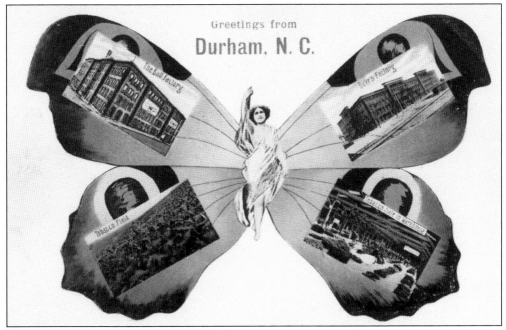

This novelty postcard, featuring a butterfly design, was produced for many cities and towns throughout the country. Reproduced on the wings of the insect are four images representing Durham's tobacco industry.

Index